TOM THOMSON

AN INTRODUCTION TO HIS LIFE AND ART

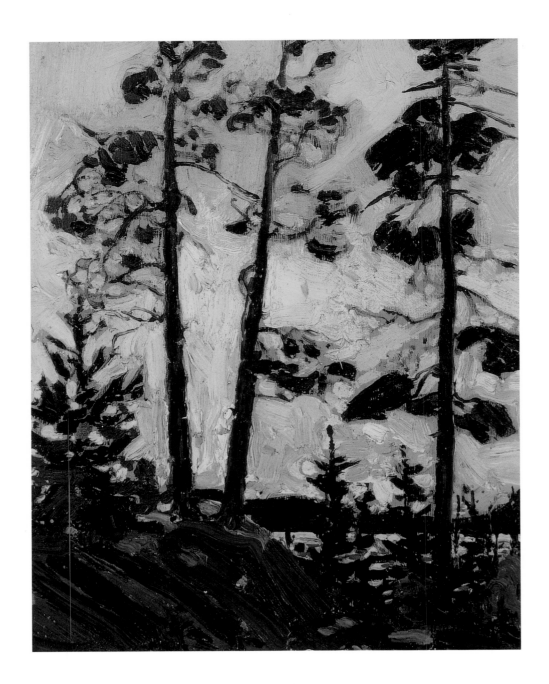

Pines at Sunset

26.7 cm x 21.0 cm (10½" x 8¼"). Private Collection.

Tom Thomson

AN INTRODUCTION TO HIS LIFE AND ART

DAVID P. SILCOX

FIREFLY BOOKS

A FIREFLY BOOK

Published by Firefly Books Ltd., 2002

First Printing

National Library of Canada Cataloguing in Publication Data

Silcox, David P., 1937–
Tom Thomson : an introduction to his life and art /
David Silcox.

Includes bibliographical references and index.
ISBN 1-55297-684-X (bound). — ISBN 1-55297-682-3 (pbk.)

1. Thomson, Tom, 1877-1917.
2. Painters – Canada – Biography. I. Title.

ND249.T5S54 2002 759.11 C2002-902148-0

Publisher Cataloging-in-Publication Data

Silcox, David.
Tom Thomson : an introduction to his life and art /
 David P. Silcox. — 1st ed.
[64] p. : ill. (some col.) ; cm.
Includes bibliographical references and index.
Summary: A general introduction to the life and art
 of Tom Thomson.
ISBN 1-55297-684-X
ISBN 1-55297-682-3 (pbk.)
1. Thomson, Tom, 1877-1917. 2. Painters – Canada –
Biography. I. Title.
759.11 B 21 CIP ND249.T5S55 2002

Published in Canada in 2002 by
Firefly Books Ltd.
3680 Victoria Park Avenue
Toronto, Ontario M2H 3K1

Published in the United States in 2002 by
Firefly Books (U.S.) Inc.
P.O. Box 1338, Ellicott Station
Buffalo, New York 14205

FRONT COVER:
The West Wind
Oil on canvas, 120.7 cm x 137.5 cm (47½" x 54⅛")
Art Gallery of Ontario, Toronto

BACK COVER:
In the Northland
Oil on canvas, 101.7 cm x 114.5 cm (40⅝" x 45⅞")
Gift of the Friends of the Montreal Museum of Fine Arts.
Photo by Denis Farley / MMFA

TITLE PAGE
J.E.H. MacDonald, *Tom Thomson Studio Stamp*, 1917

All Tom Thomson's works are oil on board or panel unless otherwise noted.

Design: Counterpunch / Linda Gustafson
Printed and bound in Canada by
Friesens,
Altona, Manitoba

*The Publisher acknowledges the financial support of the Government of Canada through the
Book Publishing Industry Development Program for its publishing activities.*

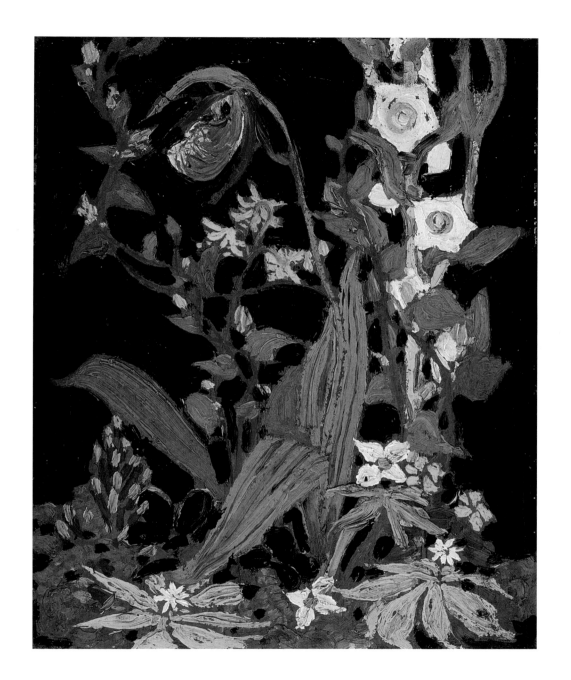

Moccasin Flower

26.7 cm x 21.6 cm (10½" x 8½"). Private Collection.

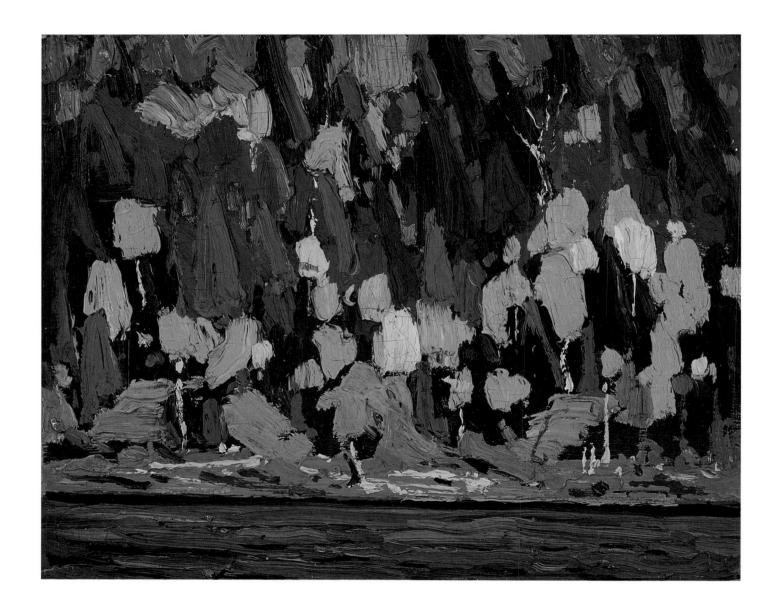

Cedars and Pines

21.6 cm x 26.7 cm (8½" x 10½"). Private Collection.

Contents

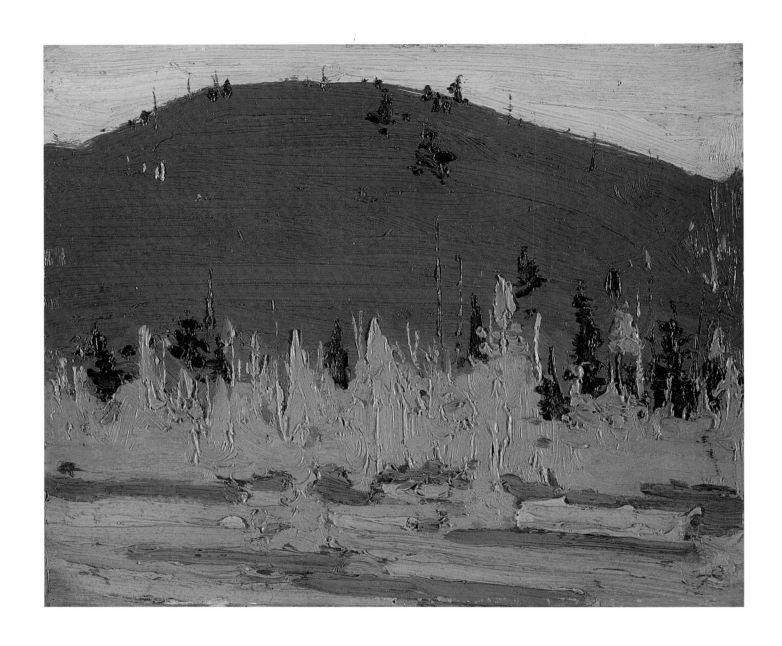

Tamarack

21.6 cm x 26.7 cm (8½" x 10½"); National Gallery of Canada, Ottawa.

Introduction

Tom Thomson is a Canadian hero, undisputed. His stature in the history of Canadian art, his role in giving the nation a sense of identity, his well known, evocative images, all contribute to the legend of this man who created lasting work during a short life.

Thomson's reputation is due to two things which are somewhat at odds with each other: his art and his untimely death. His art is glorious, although his productive years were few, less than five really, and the number of works not large – only about twenty canvases and less than three hundred small oil sketches – a fraction of what might have been.

His death occurred during the horror of the First World War. Although his drowning in Canoe Lake was probably a simple accident, no one wanted to believe that someone who promised so much could be taken away so casually. Lawren Harris and others suspected foul play. Despite the war, Thomson's death precipitated what became, over the years, a national fixation. Books about his life and untimely death sanctified him. His habits and skills were exaggerated, his relatively modest ways were magnified. He became a hero of mythic proportions, a pathfinder who, it was claimed, led Canada's imagination out of colonial servitude and into modern nationhood.

Thomson's reputation was based upon enough achievement, ability, and personality to trigger this adulation, however swollen it became with time. People interpreted his love of wilderness camping into a declaration that he was a conservationist, whereas he was excited by the lumber business. He was described in admiring phrases as an intrepid and almost superhuman canoeist and bush traveller, yet he had capsized more than once, having learned to canoe barely five years before he drowned.

In all the writing about him his art was mentioned only briefly. Sixty years after his death, only a score of his paintings had been reproduced in colour. The charm, power, and wonder of his artistic achievement was finally revealed in 1977 in *Tom Thomson: The Silence and the Storm*, a book in which the late Harold Town and I reproduced 177 works in colour, 148 of them for the first time, and many to the size of the page-size panels Thomson used.

Thomson is Canada's best-known artist and in many ways *the* best. His colleagues, who formed the Group of Seven after his death, had greater skills in many aspects of painting. Yet Thomson's intuitive grip on the spirit of place, his original palette, and his driving expression, put him in a class all by himself.

One: The Beginnings

CHILDHOOD AND GROWING UP

Thomas John Thomson was born into a large family, the sixth of ten children and the third of six sons (one died at birth), on 4 August 1877, in a small stone farmhouse near Claremont, Ontario, about seventy kilometres northeast of Toronto. When he was two months old, John and Margaret Thomson

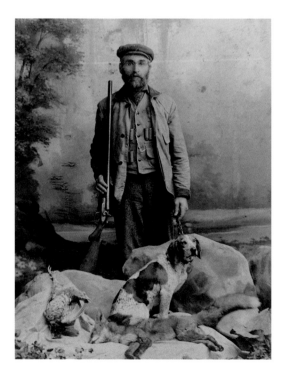

John Thomson, Tom Thomson's father

moved to Rose Hill, a farm near Leith, Ontario, a small town on Georgian Bay, not far from Owen Sound at the foot of the Bruce Peninsula. Here Thomson grew up and went to school.

Thomson had "a normal, healthy" boyhood, according to his father. Hunting and fishing were regular pastimes for him, as they were for his father, and one boyhood chum remembered Thomson as being "born with a shotgun in one hand and a fishing rod in the other." He persuaded his father to get a hunting dog.

At one point during his schooling, Thomson was kept at home for a year, apparently due to "weak lungs" or "inflammatory rheumatism." Whatever the cause, it provided the excuse for him to roam the countryside, fishing, hunting, and exploring.

As absorbing for Thomson as the countryside around him was the literature available at home. The family selection of books, which his mother had acquired, included Walter Scott, Robert Burns, Maurice Maeterlinck, and Ella Wheeler Wilcox among others. An emphasis on poetry was strong, and its influence showed in Thomson's later choice to illustrate poems by Burns, Maeterlinck, and Wilcox. Even as an adult, Thomson's love of poetry was noted by his friends and fellow artists.

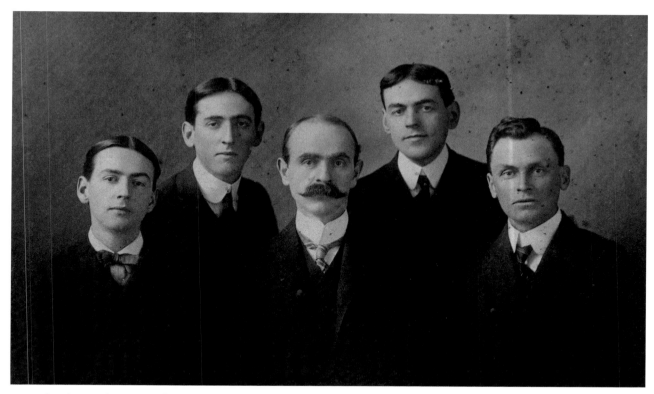

The Thomson brothers. Left to right: Tom, Ralph, George, and Henry, with Tom Harkness.

Going to church was a regular and mandatory part of the Thomson family life, so a thorough knowledge of the Bible would also have been gained beginning in his earliest years.

Although Thomson completed elementary school, and probably all or most of high school, he did not go on to university. This was a later regret in his life, and one that he more than once felt acutely, especially when he met those who had a broader education. His lack manifested itself in two ways. First, he had an almost compulsive thirst to learn, always in fits and starts, sometimes staying up all night to read a book he liked.

Second, he had a low opinion of his own work, a conviction from which his friends found it difficult to shake him.

His brothers, George, Fraser, Ralph, and Henry, and his sisters, Elizabeth, Louise, Minnie, and Margaret, also loved music. Most of them, including Tom, sang in the Leith choir and probably at church. Most of them also painted and drew. George later made a reputation for himself as a painter. Even as a young boy, Thomson was addicted to sketching – drawing in hymn books at church, and making portraits of people in the community – but since his sisters were hard-pressed to

Portrait of Tom Thomson.

EARLY YEARS

When he reached the age of twenty-one, Thomson inherited $2000 from his grandfather – a considerable sum in 1898. He seems to have spent it fairly quickly, a characteristic of his later life. He also tried three times to enlist in the army, in order to fight in the Boer War, but he was found unfit for service – for medical reasons that were never specified, although flat feet and respiratory problems were mentioned.

In 1899, at age twenty-two, he apprenticed as a machinist with William Kennedy and Sons in Owen Sound, where he stayed for eight months. He joined the Ancient Order of Foresters, a fraternal organization that was both a social club and one that provided its members with life insurance and burial guarantees.

After a brief interval at home, he followed two of his older brothers and enrolled in the Canadian Business College in Chatham, Ontario, a small town between Toronto and Windsor. He stayed only a year, studying the usual subjects, such as bookkeeping.

One of the skills taught at the business college was penmanship, although the expectation that Thomson's own handwriting might have developed into an elegant style is not borne out by his few surviving letters. They are fairly ordinary, both as to elegance of hand and sophistication of expression. Even the few paintings he signed have a clumsy block letter signature.

guess the subject, one can surmise that Thomson's ambition exceeded his abilities at this early stage.

Nothing in these years pointed to the exceptional talent that was being nourished. Thomson's childhood and adolescence did not reveal a prodigy, nor did they stifle his imagination.

SEATTLE

In 1901, after a year at the Canadian Business College, Thomson followed his brothers to Seattle, Washington, where his brother George had helped to establish the Acme Business College. After taking penmanship for six months, Thomson quit and went to work for Maring and Ladd, a photo-engraving firm. Maring was a Canadian and Thomson boarded at his home, remaining there even after going to work for the rival Seattle Engraving Company for higher wages.

The rebuff of his marriage proposal to Alice Lambert may have been the cause of Thomson's sudden return to Canada. Miss Lambert was the highly strung daughter of a Seattle minister who, later in life, wrote several novels. Although she and Thomson were fond of each other, she laughed nervously when Thomson proposed – perhaps with some justification, since she was about fifteen and Thomson, by that time, was twenty-seven. He took her reaction amiss and was reported to have left town the next morning.

Thomson's interest in art began, tentatively, to take hold during his three years in Seattle. Of whatever work he did, little remains, and most of it was commercial. Indeed, none is "artistic" in the "fine art" sense of the word. His self-portrait, below, is capable, but not distinguished. Clearly, Thomson was becoming a competent illustrator, even if the signs of his becoming an artist were few.

Whatever the cause of Thomson's return to Canada, he felt the need to be closer to his home and the country that he knew best, and he now had the skill and experience as a commercial artist that would allow him to earn a living. Still, no one at that point would have guessed that he would become an artist.

End of a letter with self-portrait; c. 1902; McMichael Canadian Art Collection, Kleinburg

TORONTO

Thomson returned to Canada from Seattle and settled in Toronto in late 1904 where, until 1914, he lived in a variety of boarding houses. He loved Toronto. Toronto was where he made a living, found friends and supporters, learned to become an artist, painted all his major canvases, and sold his paintings. Here he was close enough to Owen Sound that he could easily visit his family for weekends from time to time.

Toronto was also where he went to exhibitions, concerts, boxing matches, baseball games, the theatre, the cinema, and played football. In its libraries he found books to devour, and volumes of poetry that gave him solace and inspiration.

Poetry and music, as in his childhood, were an integral part of his adult life. From various recollections, Thomson is reported to have played the cornet, the trombone, the violin, the organ, the drums, and the bass horn. His most constant companion was a mandolin, and one posthumous illustration shows him plucking a banjo.

Thomson was also something of a dandy. He had a penchant for sophistication and liked going to places like George S. McKonkey's elegant restaurant, a favourite place for artists to gather. He sported silk shirts, bought expensive pipes and tobacco, and used the best painting materials available.

Remembering another side of Thomson's life in Toronto, Lawren Harris wrote, "When he was in Toronto, Tom rarely left the shack in the daytime and then only when it was absolutely necessary. He took his exercise at night. He would put on his snowshoes and tramp the length of the Rosedale ravine and out into the country, and return before dawn."

The Don and Humber River valleys then were still chiefly forested, with occasional farms. Atlantic salmon still spawned in both in the spring. The opportunity for outdoor sketching was virtually on Toronto's doorstep, and Thomson and his commercial art friends made sketching trips along the rivers, to nearby Lake Scugog and Lake Simcoe. This shift from commercial art to artist was made, finally, in his early thirties — an age at which Paul Peel died, Raphael had completed most of his great works, and Picasso, after more than a decade of achievement, had already moved on to cubism.

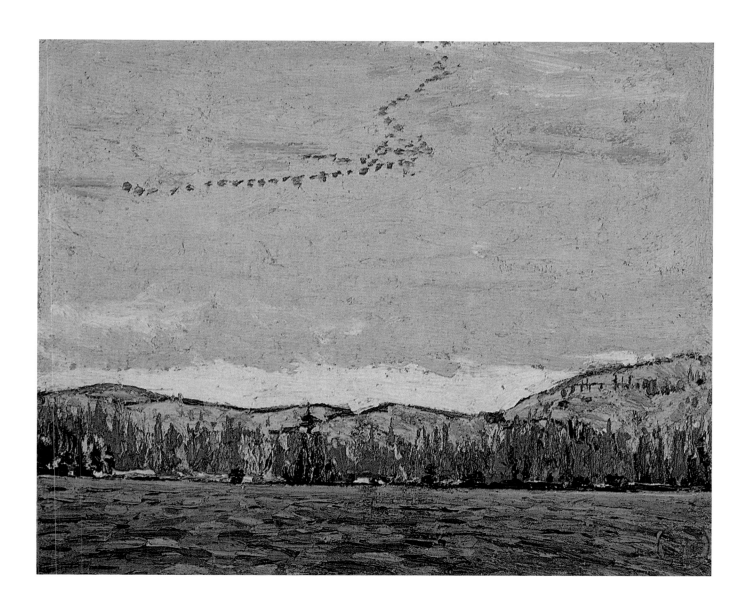

Wild Geese

21.6 cm x 26.7 cm (8½" x 10½"); Museum London, London, Ontario.

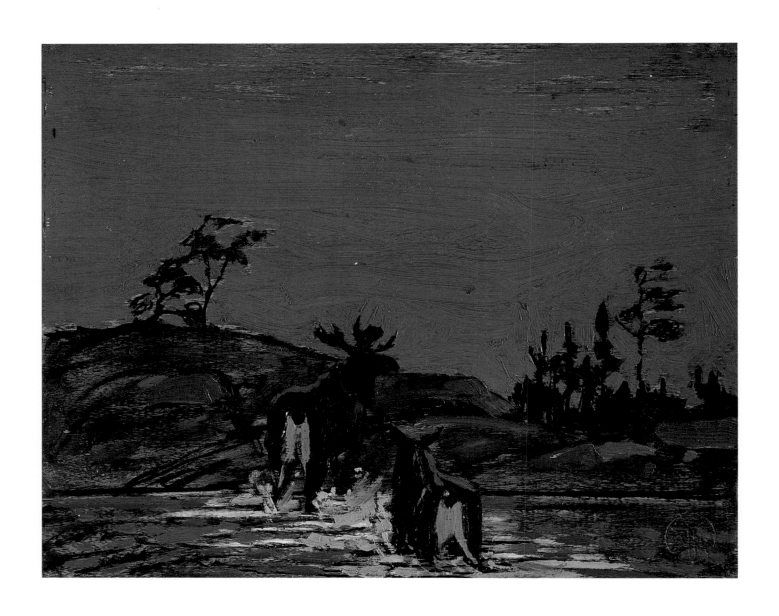

Moose at Night

21.6 cm x 26.7 cm (8½" x 10½"); National Gallery of Canada, Ottawa.

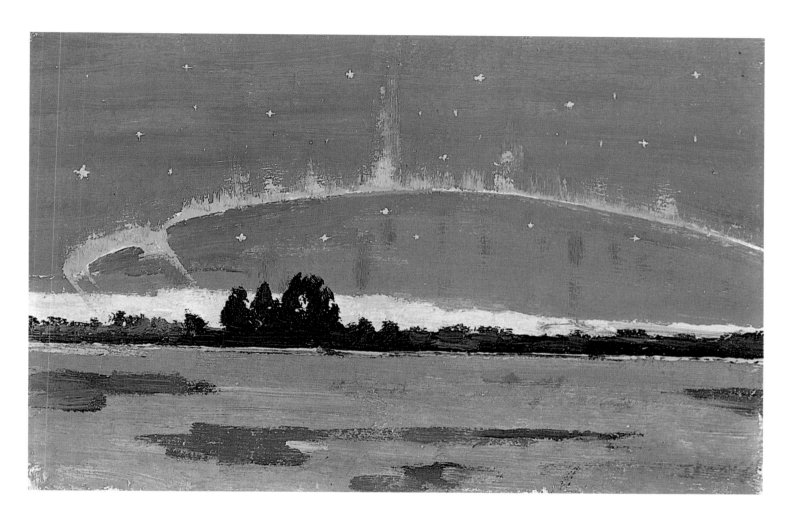

Northern Lights

16.2 cm x 25.1 cm (6⅜" x 9⅞"); Tom Thomson Memorial Art Gallery,
Owen Sound.

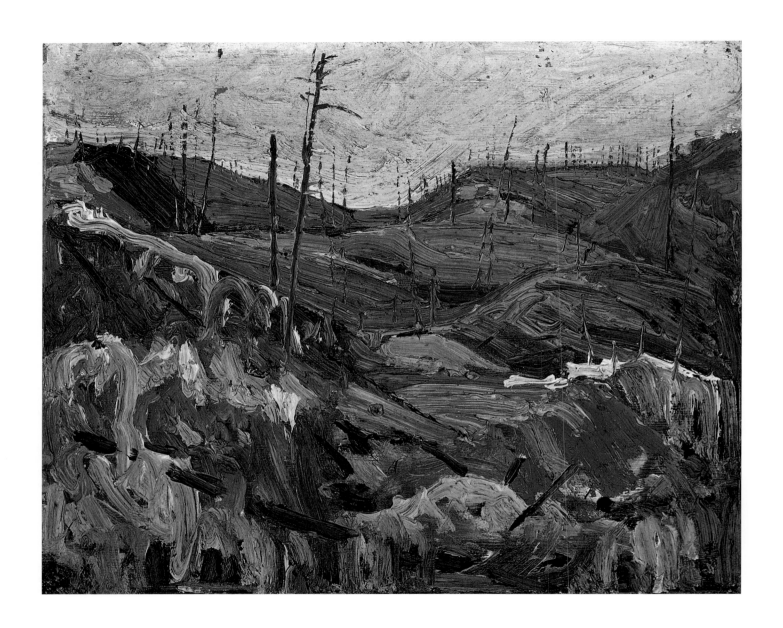

Fireswept Hills

21.6 cm x 26.7 cm (8½" x 10½"). Private collection.

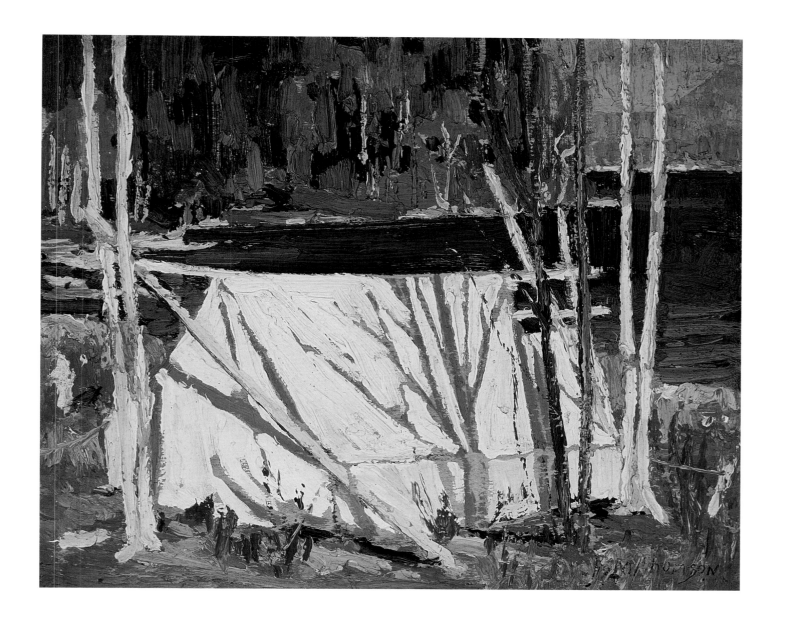

The Tent

21.6 cm x 26.7 cm (8½" x 10½"). Private collection.

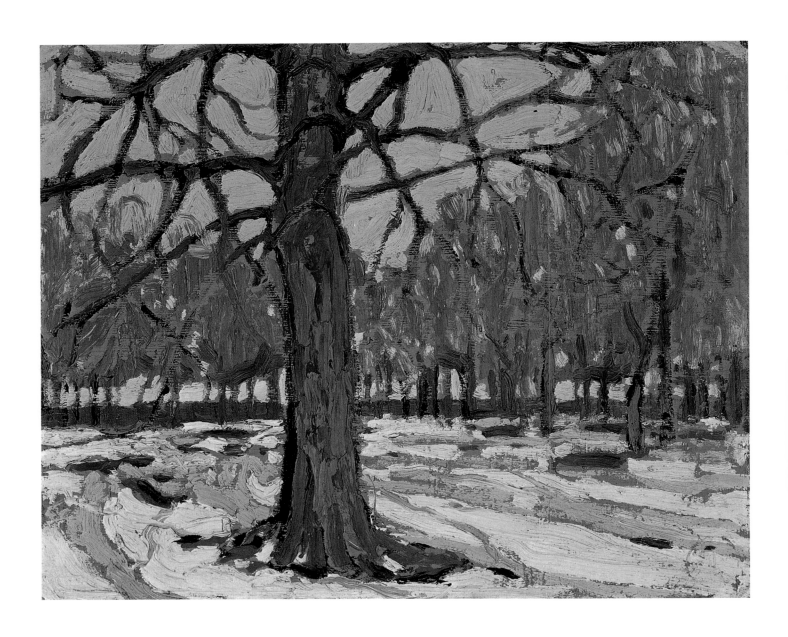

First Snow

21.6 cm x 26.7 cm (8½" x 10½"); Agnes Etherington Art Centre,
Queen's University, Kingston.

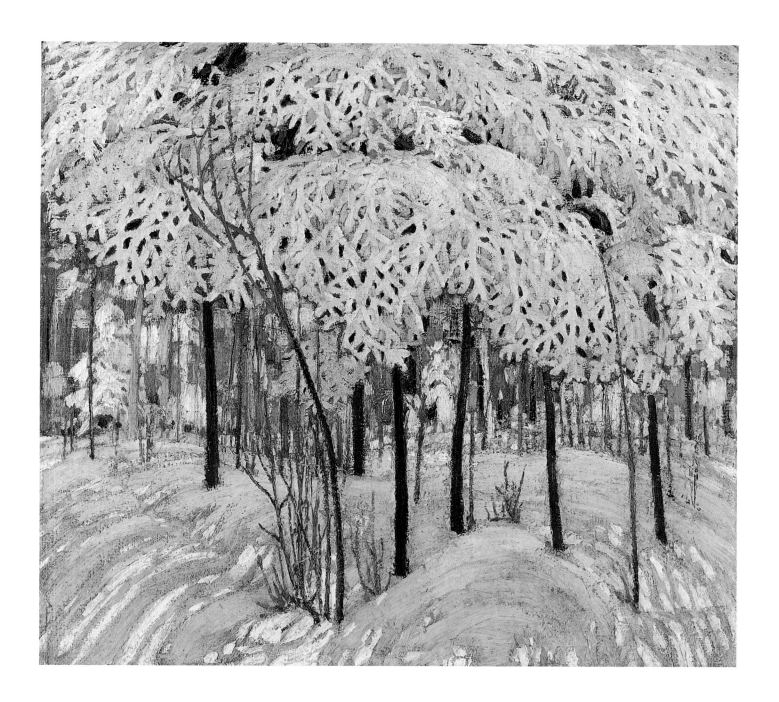

Snow in October

Oil on canvas; 81.9 cm x 87 cm (32¼" x 34¼"); National Gallery
of Canada, Ottawa.

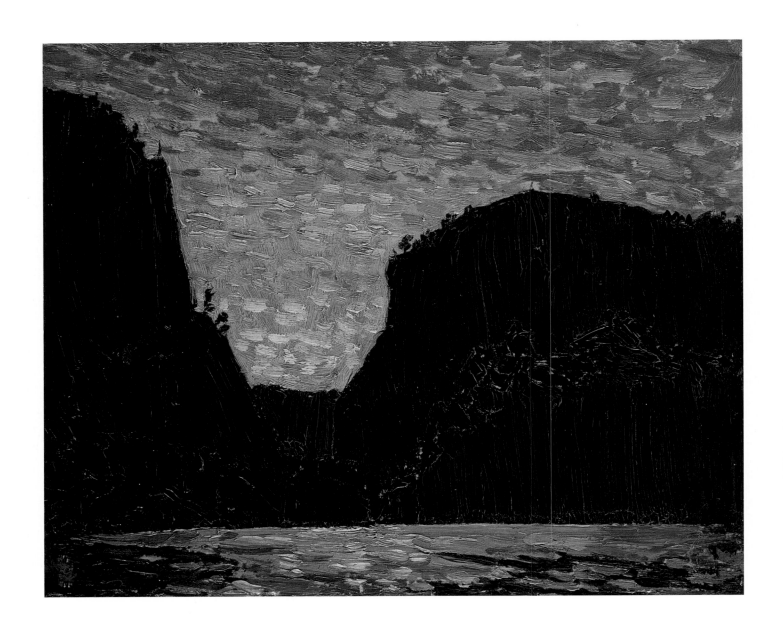

Petawawa Gorges, Night

c. 1916–17; 21.6 cm x 26.7 cm (8½" x 10½"); National Gallery of Canada, Ottawa.
Vincent Massey Bequest, 1968. No. 15548.

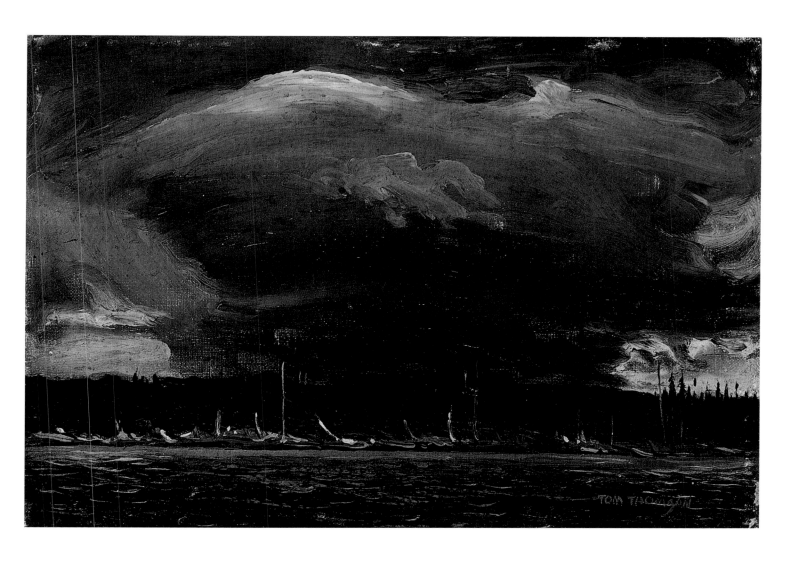

Thunderhead

17.5 cm x 25.1 cm (6⅞" x 9⅞"); National Gallery of Canada, Ottawa.

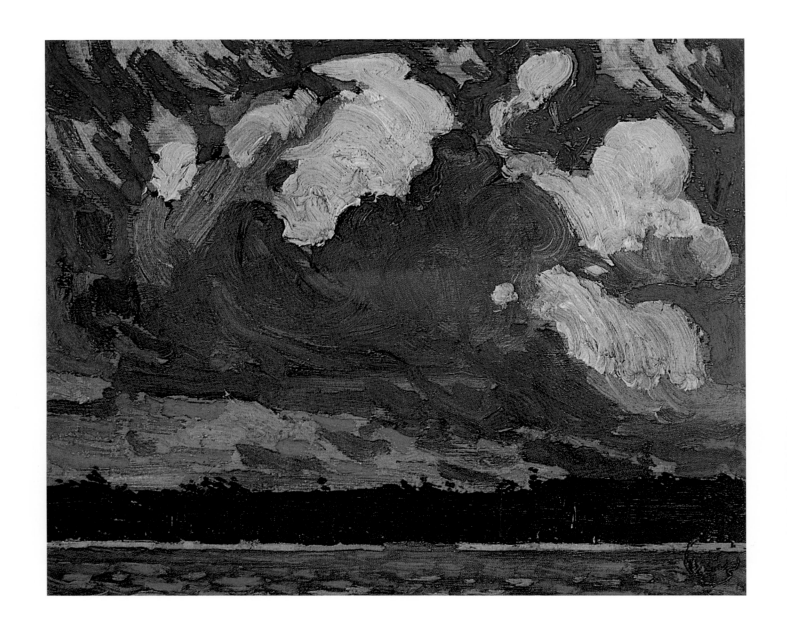

Storm Cloud

21.6 cm x 26.7 cm (8½" x 10½"). Private collection.

Two: The Formative Years

COMMERCIAL ART

When he arrived in Toronto, Thomson had behind him his training at two business colleges and three years of work at two photoengraving companies in Seattle. With this experience he was able to get work, and he moved restlessly among several design shops: Legge Brothers, Grip Limited, Rous and Mann, and possibly Reid Press in Hamilton, Ontario. At these companies he would have become thoroughly familiar with a wide variety of printing and reproductive techniques of the day: lithography, photography, etching, and letterpress among them. His colleagues were men knowledgeable about art and design, and in many cases artists who painted in their spare time while their commercial work paid the mortgage.

Toronto was then the centre for publishing in Canada, and its design, engraving, and printing firms were both busy and competitive. They turned out advertising materials in great quantity and with remarkable speed and employed a large number of men with various special skills. What was needed for advertising or packaging anywhere in the country, for the railways, the food industries, clothing, and practically everything else, came from Montreal or Toronto.

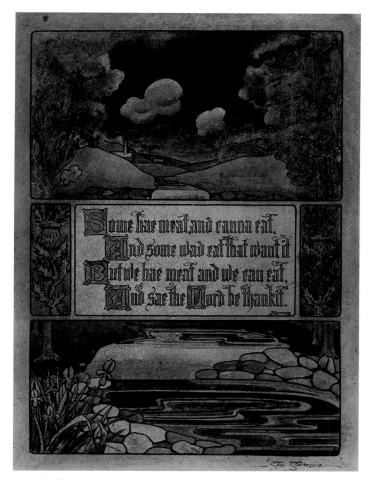

Burns' Blessing; c. 1907, *watercolour and ink on paper; 30.5 cm x 22.8 cm (12" x 9"); Tom Thomson Memorial Art Gallery, Owen Sound.*

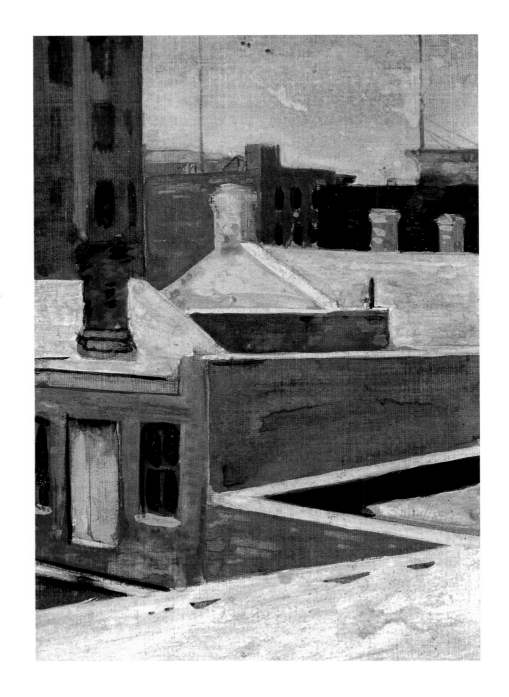

View from the Window of Grip

Watercolour on paper; 15 cm x 10.2 cm (5⅞" x 4"). Private collection.

When he was taken on at Grip Limited, in 1907 or 1908, Thomson had the tedious job of socking in the dots and tints on the Ben-Day plates. He soon proved himself as an adept illustrator and excelled at lettering. Grip, one of the leading houses of the day, was managed by Albert Robson, who had a keen eye (much overrated, according to A.Y. Jackson) for talent.

Thomson met remarkable people at Grip. The artist William Broadhead, with whom he first travelled in northern Ontario, was one. Ben Jackson, who first took him to Algonquin Park in 1912 was another. Rowley Murphy, an accomplished painter, who introduced him to watering places around Toronto, was another employee who would have expanded Thomson's artistic and intellectual horizons. All were talented commercial artists who pursued their work as fine artists after shop hours. Even Lawren Harris, who did not need the money, began his career doing travel magazine illustrations.

Most importantly, Thomson met J.E.H. (Jim) MacDonald, probably the finest design talent in Canada at the time. MacDonald invited Thomson along on weekend sketching trips and was instrumental in persuading him that the rewards of painting were worth the effort and time involved and that he, Thomson, had the ability to succeed as a painter. Thomson may have taken some painting lessons about this time, probably from William Cruikshank, "a cantankerous old snorter" according to A.Y. Jackson, who was fairly cranky himself.

The impact that commercial art had upon the art of the circle that developed around Thomson, MacDonald, Harris, and their friends, was profound. At its worst, it turned potentially large ideas

Tom Thomson's business card

into banal illustrations. At its best, the commercial impulse gave coherence and punch to their painting that it might otherwise have lacked.

THE ARTS AND LETTERS CLUB

The Arts and Letters Club was established in Toronto in 1908. Men interested in the arts gathered there for lunch every day and often for dinners and special evenings of theatre, concerts, lectures, and readings.

Exhibitions of paintings were planned regularly. Before too long the club was issuing its own little periodical, *LAMPS*, which stood for Literature, Architecture, Music, Painting, and Sculpture.

Through MacDonald, who was only four years his senior, Thomson became a regular at the Arts and Letters Club. Harris met MacDonald and Frank Johnston there. Later, MacDonald brought in Arthur Lismer, Frederick Varley, and Jackson. This fraternity of commercial artists would also have frequented some of the bars and restaurants of the city regularly.

J.E.H. MacDonald was an active member, since the club gave him a focus for his interest in all the

arts. He called the Club "a blessed centre for me in this grey town." In 1911, soon after returning to Toronto after studies and travels abroad, Harris, a founding member, saw a little exhibition of MacDonald's work at the club. He was bowled over by it because he thought that MacDonald was painting Canada "in its own spirit" – a style that seemed to shuck off the burden of foreign influences or at least absorb them into a vision of painting unique to Canada. They met and became fast friends, sketching together around Toronto and in the countryside nearby, and plotting the development of a new direction for Canadian art.

Thomson was a part of the activities of the Arts and Letters Club and soon met artists who were to influence his life even more than his earlier years in Toronto had. Arthur Lismer arrived in Canada from England in 1911. A year later Frederick Varley, also from Sheffield, was in Toronto and was a member of the club. Frank Johnston attended, and so, in 1913, did A.Y. Jackson. When he came to Toronto to work in commercial art in 1914, Franklin Carmichael became a member. Except for Jackson, who had worked in lithography shops in Montreal and Chicago, all these men worked at Grip Limited or at Rous and Mann as commercial artists.

Thomson had his first exhibition at the Arts and Letters Club in 1911, arranged by J.E.H. MacDonald, and exhibited again in 1915, although by this time he had exhibited in the society shows for two or three years and was a known, if recent, presence in the art world of Toronto.

FORMATIVE INFLUENCES: J.E.H. MACDONALD

The two artists who set Thomson on the path to becoming an artist were J.E.H. MacDonald and Lawren Harris. Both men were innovative painters, both wrote poetry, and both were, or became committed to, transcendental ideas and, in Harris's case, to theosophy, a movement based on spiritual attainments and universal brotherhood.

MacDonald was a brilliant designer, painter, poet, and writer and the first to see possibilities in Thomson. An endlessly enthusiastic proselytizer, MacDonald had a comprehensive view of the importance of the arts, and his convictions were strong. The interrelation of the arts was something he saw clearly, and he was an inspiring teacher. The transcendental writings of Ralph Waldo Emerson and Henry David Thoreau (after whom he named his son) led him to try to achieve a spiritual dimension in painting the Canadian landscape, a goal that did not elude him. He brought a powerful concentration to bear on the possibilities of his own painting and on the formation of a national school of artistic expression.

MacDonald had been born in England, but his Canadian father had brought the family back to Canada when MacDonald was fourteen. After training as a commercial artist he returned to England for three years. There he learned about contemporary art, and was thoroughly familiar with English traditions. Thomson's debt to the English painter John Constable, especially in his treatment of clouds, came to him first through MacDonald and was shortly reinforced by Arthur Lismer, who graduated from the same tradition.

FORMATIVE INFLUENCES: LAWREN HARRIS

Lawren Harris, an heir to a fortune from the Massey-Harris farm implement company, became the visionary leader who, after it was formed in 1920, defined the Group of Seven's ideas about the nature of the Canadian landscape and the north. His father had died when he was still a small boy, and his mother had moved from Brantford, where he was born, to Toronto. After a brief stint at the University of Toronto, he studied art in Berlin and then returned to Toronto in 1908.

In 1911, after seeing an exhibition of his work at the Arts and Letters Club, Harris met J.E.H. MacDonald. Shortly thereafter, through MacDonald and James MacCallum, Harris met Arthur Lismer, Franklin Carmichael, Tom Thomson, and Frank Johnston.

Harris, a strong nationalist and a committed spiritualist, was captivated by the ideas of theosophy. His ambition to awaken and define the Canadian spirit found an outlet in his own work and in his support of painters like Thomson. Harris gave Thomson encouragement, books to read (usually dealing with spirituality) and arranged for his work to be purchased.

In early 1913, Harris and MacDonald visited an exhibition of contemporary Scandinavian art in Buffalo, and came home enthused about how the Canadian northland might be painted. The information they conveyed to Thomson and other colleagues fuelled their ambition to create a national art based on Canada's "northern" character.

Whereas MacDonald was undoubtedly the

inspiration for Thomson to apply himself to the profession of painting, it was Harris who provided the vision within which Thomson found his true path as an artist. Harris not only recognized and encouraged Thomson's innate passion for the north, but he articulated it, giving it a structure and a context that it otherwise would not have had.

Harris was a persuader. He was an effective advocate, a man of means, well connected with powerful people, politicians, society people, industrialists, bankers, and others. He lived next door, practically, to art patron Vincent Massey and shared his fellow-heir's ambitions for Canada.

Harris was both a visionary and a practical man. He wrote articles, made speeches, gathered people together, and spurred others to action. Without him there never would have been a Group of Seven (they met to form the Group in Harris's house at his invitation) and certainly there would not have been the Tom Thomson we know today.

Harris's support of Thomson was to have important consequences for Harris. Having taught Thomson, fed his ambition, nursed his talent, and given him numerous ideas about painting, within a few years Harris was learning from Thomson about attack, boldness, colour, and bravado. Without Harris, Thomson might never have become the artist we know, and without Thomson, Harris might never have developed the intense passion for the north that nourished the driving force behind the Group of Seven.

DR. JAMES MACCALLUM: PATRON EXTRAORDINARY

In 1911, through Harris, Thomson met Dr. James MacCallum, who was to become his generous patron. If Harris and MacDonald were the hinges upon which Thomson's future swung, MacCallum certainly was the one who pushed open the door of Thomson's talent.

Dr. James MacCallum, an ophthalmologist who taught at the University of Toronto, was Thomson's strongest supporter. A good friend of Harris's, MacCallum introduced Harris to other young artists and then invested with Harris in the construction of the Studio Building. MacCallum was interested in Thomson, especially when he began to concentrate on paintings of the north.

MacDonald and Harris had already seen the talent in Thomson, and had helped him to learn more about the magic and the power of painting. Thomson's ability had, finally, emerged in 1910 and the years following – stronger in 1911, emphatic and promising in 1912, astonishing in 1913, and potent and brilliant for the last four years of his brief life.

MacCallum had no grounding in art history nor any training as an artist himself. What he was, however, was a committed, enthusiastic, and loyal supporter of the artists who later became the Group of Seven. His love of the north, which for him was centred on his cottage at Go Home Bay on Georgian Bay (where many University of Toronto professors had summer retreats), put him at one with the fundamental aim of those who became the Group of Seven. To give expression

to the north was Harris's constant theme and the basis for all that ensued for Thomson and the Group of Seven.

In the fall of 1913 MacCallum took an unusual step: he offered to absorb Thomson's living and materials expenses for a year so he could devote his whole time to painting. MacCallum made the same offer to A.Y. Jackson to keep him from going off to the United States. Thomson was doubtful and reluctant to accept, since he did not yet consider himself an artist and was not confident of his own abilities. Jackson underlined this aspect of Thomson's character: he "was dubious about his ability to make a living out of his painting, doubtful also about his own talents." However, he was finally persuaded to accept the offer and his art flourished from that moment on.

DR. JAMES MACCALLUM: PRESERVER OF THE LEGACY

MacCallum thought that Thomson was a genius. In one respect he was right, because Thomson, for the short time he was the artist we all know and admire, embodied the essential spirit of the Group of Seven in his work. MacCallum thought of Thomson's work as being an "Encyclopedia of the North" and some reference was made by Mark Robinson, an Algonquin Park ranger and friend, about Thomson having painted a sequence of sixty-two sketches on the daily arrival of spring – a project that, if it ever was undertaken, was certainly never presented as such, and would be impossible to reconstitute.

MacCallum commissioned murals for his cottage by MacDonald, Thomson, and Lismer. These

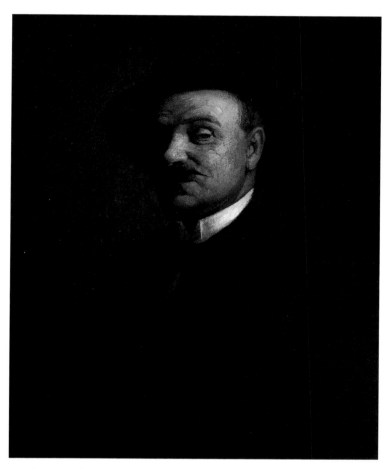

Curtis A. Williamson; Portrait of Dr. J.M. MacCallum ("A Cynic"); *1917; oil on canvas; 67.5 cm x 54.9 cm (26½" x 21½"); National Gallery of Canada, Ottawa.*

were painted and installed in 1916. The MacCallum cottage was always available to these painters, and MacCallum later accompanied the members of the Group on some of their outings to Algoma, and went fishing with Thomson in Algonquin Park. He was also part of many of their gatherings in Toronto.

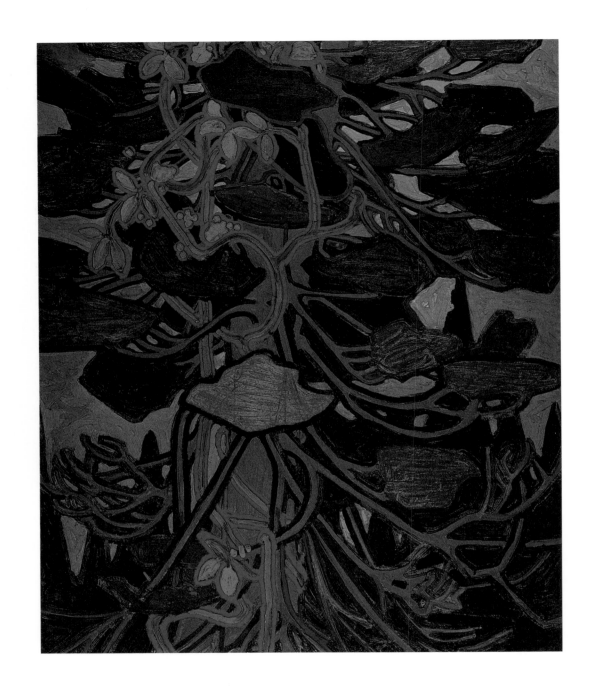

Decorative Panel I

120.6 cm x 96.5 cm (47½" x 38"); National Gallery of Canada, Ottawa.

After Thomson's death in 1917, MacCallum looked after his modest estate. The oil sketches on panel, some three hundred of them, "were stacked in a tall set of shelves marked Snow, Sunset, Summer, Fall and so on." MacDonald branded all them front and back with a logo he devised from Thomson's initials (TT) and the year of his death, 1917. MacCallum set about listing and storing the canvases, arranging exhibitions of Thomson's work, selling the paintings for increasingly high prices, badgering institutions to acquire them (he sold *The Jack Pine* to the National Gallery for $750 in 1918 and *The West Wind* for $1,500 in 1920), and promoting Thomson's unique contribution to Canada's sense of identity.

MacCallum bought Thomson's work to support him while he lived and continued to collect his work after his death. Finally, he bequeathed the largest gift to date of Thomson's pictures to the National Gallery of Canada.

THE STUDIO BUILDING AND THOMSON'S SHACK

Lawren Harris knew that most of an artist's life is spent in the studio, making paintings from ideas gleaned from sketching trips or other sources. He realized that for the arts to thrive in Canada, artists had to apply themselves to their mission whole-heartedly, and to do that good studio space was needed. In 1913, with the help of MacCallum, Harris built the Studio Building in Toronto.

The site was 25 Severn Street, a small street which, at the time, ran east off Yonge Street into the Rosedale ravine just north of Davenport

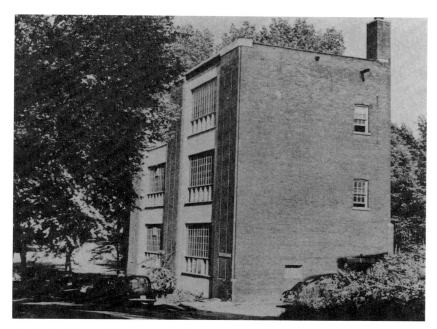

Studio Building, 25 Severn Street, Toronto.
Photo courtesy of the Art Gallery of Ontario, Toronto.

Road. Although the area was divided into lots, development was delayed because of the war and Harris was later able to buy several lots so that the area around the building subsequently became a small park.

The three-storey brick Studio Building had six large north-facing studios with fourteen-foot ceilings, huge windows (eleven feet high and fifteen feet wide), and a small mezzanine area for sleeping with rack storage underneath. The three eastern studios had fireplaces (Harris took one of these for himself) and bathrooms; the western studios had toilet facilities off the staircase on the south side.

The first artists to occupy the Studio Building were Tom Thomson and A.Y. Jackson, who shared Studio One. Following them in short order

as the building was finished were Harris, J.E.H. MacDonald (who designed and painted the directory, which hung there for many years), Curtis Williamson, Arthur Heming, and J.W. Beatty (who was there until he died in 1942). "About all that Williamson, Heming, and Beatty had in common," Jackson commented, "was a hearty dislike of one another."

After the first year, when Thomson spent so much time in Algonquin Park, he decided to move from Studio One to a shack at the back of the build-ing, one that had been used during the construction and before that had been a cabinetmaker's premise. Harris and MacCallum had it fixed up for $176.02 and rented it to Thomson at $1 per month. Thomson made his own bunk, shelves, table, and easel.

The Studio Building became the primary centre, with the Arts and Letters Club, where the artists who became the Group of Seven met most often. Lismer, Varley, and others visited regularly. It was the Group's business address, their workplace and, for several of them, Thomson among them, their home.

FORMATIVE INFLUENCES:
A.Y. JACKSON, ARTHUR LISMER,
AND FREDERICK VARLEY

Alexander Young Jackson was trained as a lithographer in Montreal and Chicago and as an artist in Montreal and Paris. When he arrived in Toronto in 1913, he was disgusted with the attitudes toward art in Montreal, and ready to migrate to the United States. Two things kept Jackson in Canada: Harris purchased his painting *The Edge of the Maple Wood*; and MacCallum made him an offer to pay his expenses for a year, the same offer he made to Thomson, if he would stay in Canada and paint full time.

Jackson and Thomson did not meet until the fall of 1913, upon Thomson's return from Algonquin Park. They briefly shared a studio in early 1914 before Jackson, persuaded by Thomson, headed for Algonquin Park himself in late February, and then headed west after March. They were together again for six weeks in Algonquin that fall, when World War I broke out. Jackson returned to Montreal and joined the army. Thomson and Jackson had known each other little more than a year, and they never saw each other again, but they each had a profound impact on each other.

Jackson is the only member of the circle that became the Group of Seven to have immersed himself thoroughly in the work of the Impressionists with his studies in France. This connection with the Impressionists through Jackson was, for Thomson, almost as potent a source of knowledge as the knowledge he got from Harris and MacDonald after their visit to the Scandinavian exhibition in Buffalo, New York, in early 1913.

The idea of colour as a source of light and the range of colour that was possible if you threw away the conventions of the academic approach, opened up for Thomson a window through which he could suddenly see a new world, a new way of dealing with the landscape of the Precambrian shield.

Lismer and Varley both hailed from Sheffield in Yorkshire and both had studied at the Royal School of Art in Brussels. Lismer had developed his own design business in England before deciding, in 1911, that Canada offered greater opportunities. He was well versed in English painting traditions as well as developments in Europe, and he brought not only this knowledge with him but also a great enthusiasm and a particular ability to articulate ideas about art. He soon developed into one of Canada's foremost art educators as well as a proselytizing painter.

Lismer persuaded Varley to move to Canada in 1912. Although from similar traditions, Varley's interest was less in the nationalistic aims that the future members of the Group of Seven had for pictures of the Canadian landscape than in people. He was the finest draftsman of them all, and his ambition was to surpass Augustus John, whose work he certainly equalled on numerous occasions. Varley's work did have a spiritual dimension and power that Thomson would have admired but, apart from the one fall trip to Algonquin Park in 1914, they did not strike as close a friendship as Thomson had with the others.

THOMSON'S CHARACTER

Thomson had an easygoing personality and nearly everyone liked him. He stood at a lanky six feet, agile, energetic, and handsome. Harris described him as "tall, lithe, and very graceful." Jackson wrote that he paddled a canoe "like an Indian," an intended compliment. Arthur Lismer said he was "refined and delicate. He had a graceful mind." Albert Robson, the manager at Grip, found him bashful and "generous to the point of a fault." Thomson reportedly loaned money to Shannon Fraser, who owned Mowat Lodge, his headquarters in Algonquin Park, and easily parted with money whenever he had it. He also gave his sketches away whenever someone admired them. Another friend said he was "instinctively a cultured person."

Thomson had a hunger for refinement and sophistication and loved well-crafted things. His favourite word of contempt was "shoddy." Using materials of superior quality was a point of honour with him, and the later disintegration of the three-ply panels he used in 1914, which are causing striations to appear in some of his paintings of that year, would mortify him. Harris remembered him as "a real craftsman. He made trolls for fishing out of piano wire; sometimes he made beads and hammered out pieces of metal which were works of art in themselves." He also decorated ceramic dishes and cups.

Thomson was as bohemian as one could be in the Toronto of the early twentieth century. He was attractive to women, and saw many but never settled on one, although apparently he was engaged to Miss Winnifred Trainor when he died. He was also not a teetotaler, and enjoyed the pleasures of many of the bars around Toronto with his chums, and sometimes drank too much.

He was given to occasional extravagant gestures, such as mixing expensive artists' pigments to paint his canoe a particular colour, and buying expensive pipes and tobacco, silk shirts, and a silk tent. He was once reported to have cashed a cheque into one-dollar bills which he then threw in the air, and to have ripped up a cheque when the bank teller, who knew him, insisted that he provide identification.

The other side of Thomson's congenial bonhomie was his melancholy and uncertainty, punctuated by occasional fits of temper. Harris referred to Thomson's "remoteness, his genius, his reticence." Jackson said he "lacked confidence as an artist." This may be a reason why he seemed not to have taken much care with his professional career. It was his friends who ensured that he entered works in the annual exhibitions of the Ontario Society of Artists, and who arranged what few exhibitions of his work there were while he was alive.

Thomson was rejected for military service in the First World War, as he had been for the earlier Boer War. This irritated him. Although he liked to have the time for painting, he knew that his friends were all in the service. He thought that at least he should do something for the war effort. Work was not as plentiful at the engraving houses, and in Algonquin Park the numbers of people needing guides for fishing had dropped significantly. Thomson thought about heading out west to help harvest the wheat on the "Harvest Excursion" in 1916 or 1917, but in the end he did not.

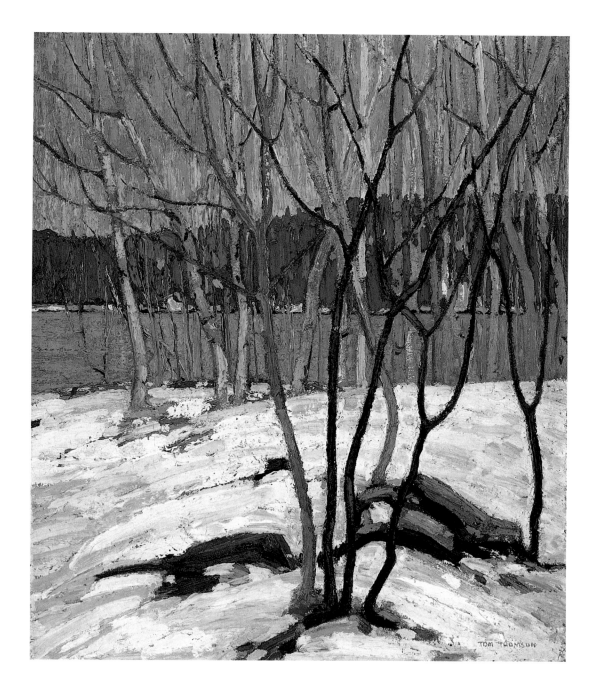

White Birch Grove

Oil on canvas; 64.1 cm x 54 cm (25¼" x 21¼"). Private collection.

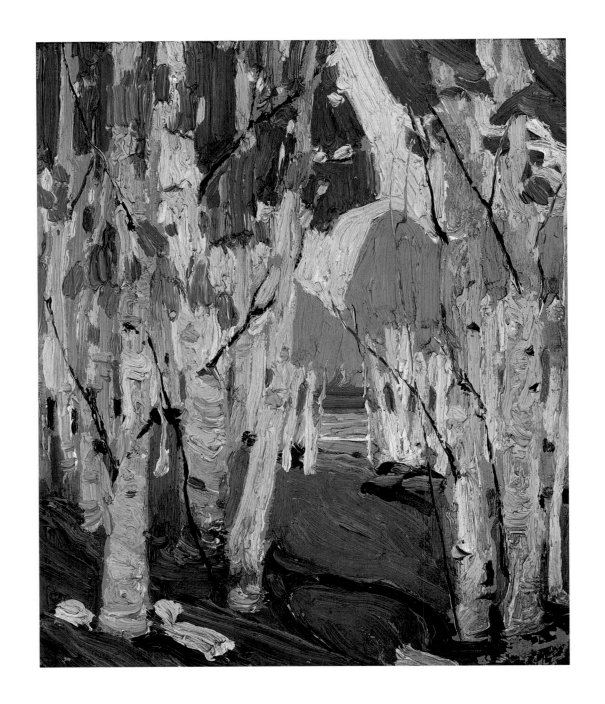

Pink Birches

21.6 cm x 26.7 cm (8½" x 10½"). Private collection.

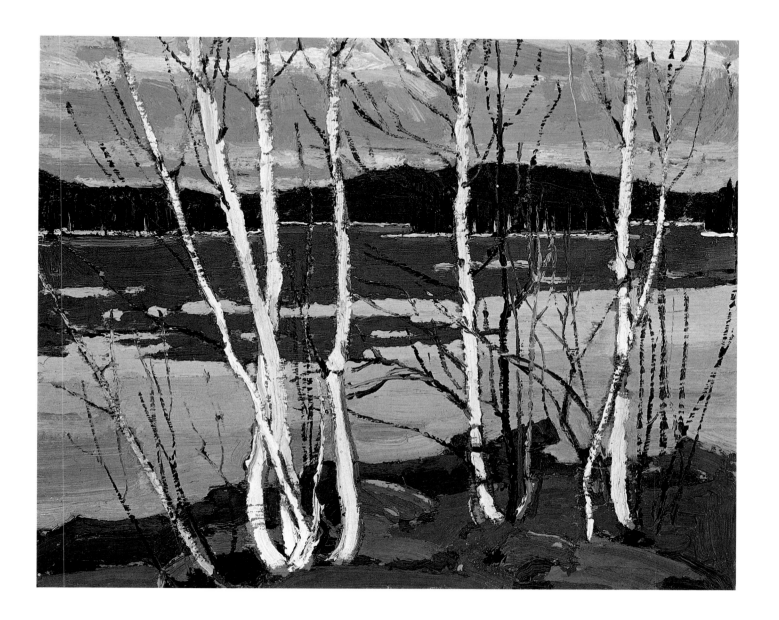

Spring in Algonquin Park

21 cm x 26 cm (8" x 10"). Private collection.

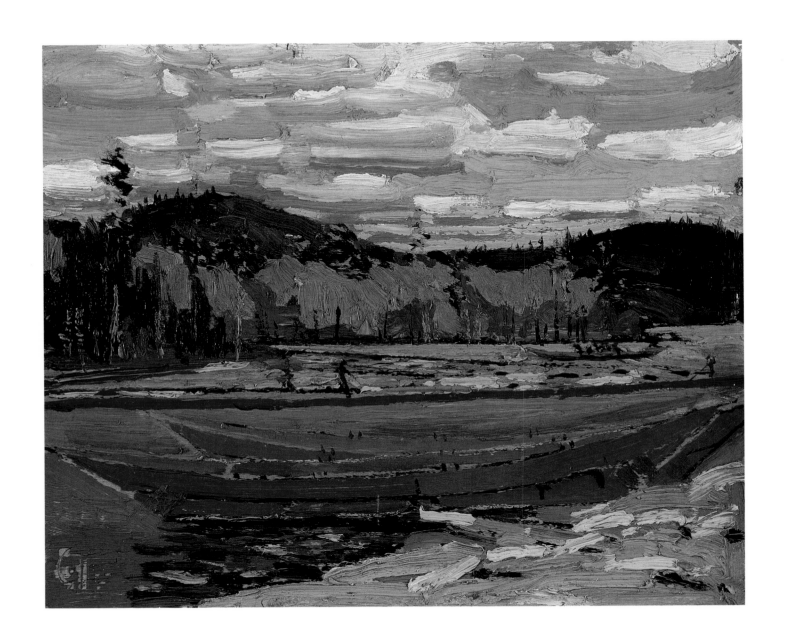

Bateaux

21.6 cm x 26.7 cm (8½" x 10½"); Art Gallery of Ontario, Toronto.

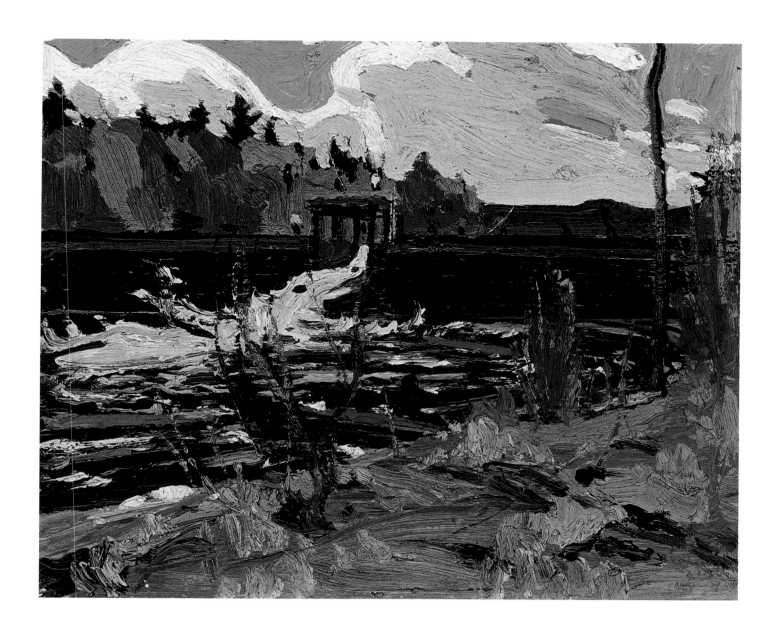

Tea Lake Dam

21.6 cm x 26.7 cm (8½" x 10½"); National Gallery of Canada, Ottawa.

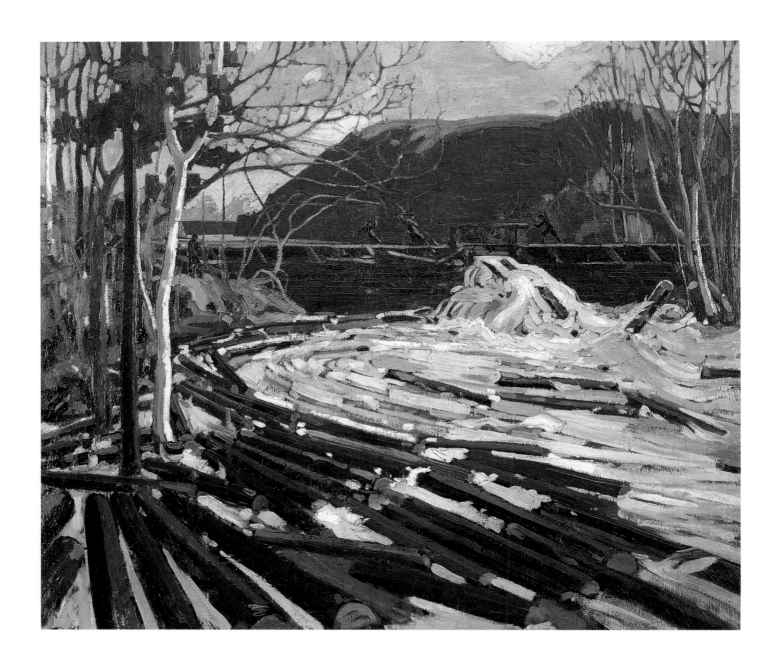

The Drive

Oil on canvas; 120 cm x 137.5 cm (47¼" x 54⅛"); Macdonald Stewart
Art Centre, Guelph.

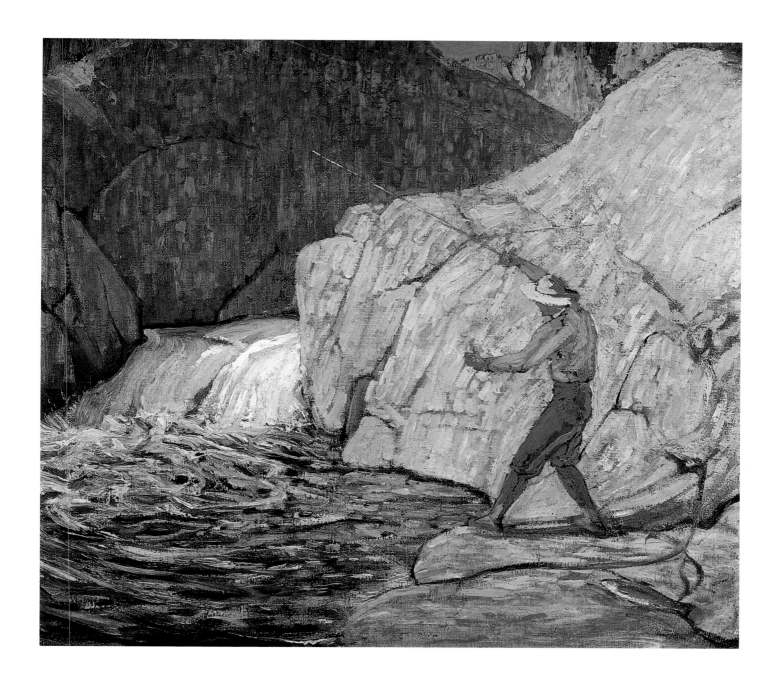

The Fisherman

Oil on canvas; 51.1 cm x 56.9 cm (20⅛" x 22⅜"); Edmonton Art Gallery.

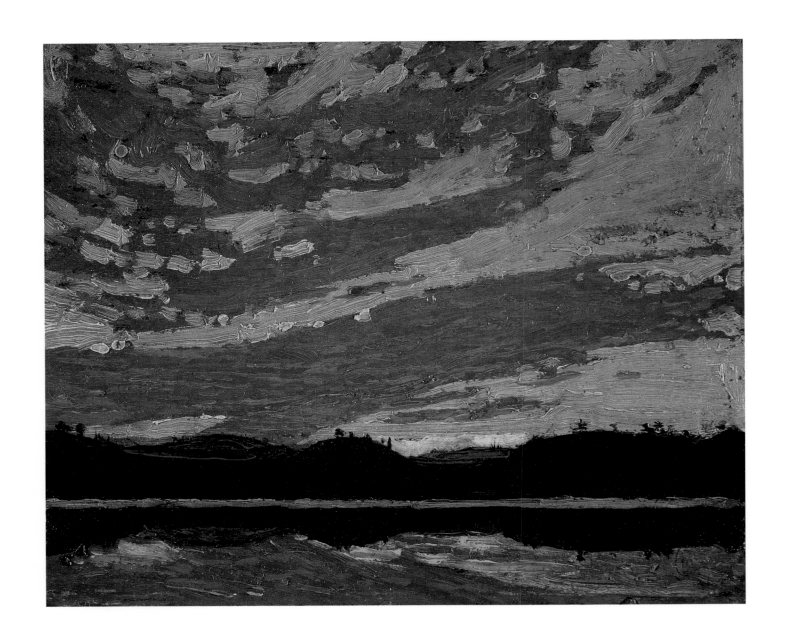

Sunset

21.6 cm x 26.7 cm (8½" x 10½"); National Gallery of Canada, Ottawa.

Three: The Fertile Years

ALGONQUIN PARK AND
GEORGIAN BAY

Algonquin Park lies about two hundred kilometres north and a little east of Toronto and is often thought to be "heartland country" for Tom Thomson and the Group of Seven. From Algonquin Park came some of their best-loved images, including Thomson's *The Jack Pine* and *The West Wind*, which were probably sketched at Grand Lake in 1916. Thomson first visited the Park briefly in 1912, spent the summer of 1913 there, and the following year enticed Arthur Lismer, Fred Varley, and A.Y. Jackson to join him in the fall. Until his death on 8 July 1917, a scant three years later, he spent spring, summer, and fall months in the Park (with winters in Toronto), apart from short trips to Georgian Bay to visit his supporter and friend Dr. James MacCallum at Go Home Bay.

Algonquin Park was first established as an enormous recreation and game sanctuary in 1893, and promoted for its restorative air – a special place for tubercular patients and other convalescents. Mowat Lodge on Canoe Lake, Thomson's "head-quarters" during his sojourns in the Park, touted its "health-compelling climate." Thomson, who had "weak lungs," may have gone there initially for

reasons of health. The University of Toronto's forestry research station was established in the Park in 1908. Telephones were installed in 1911. Over a hundred and fifty kilometres of roads and two railways sliced through this tract of splendid wilderness, and regular air patrols had began by 1921, when the Taylor Statten summer camps for children were established. The town of Mowat, close to Canoe Lake, had a population of six hundred to seven hundred souls at the turn of the century, but later declined with the bankruptcy of a lumber firm and no longer exists.

A civilizing aspect of the Park was the presence of four large, luxurious hotels, where city "toffs," as Arthur Lismer called them, holidayed in the summers – donning formal wear for dinner, and enjoying the glories of the bush with the amenities of urban life always at hand. Such resorts, which were popular at the time, could be found in many places in Canada served by the railway – at Bon Echo, Muskoka, Lake Temagami, Madawaska, Lake of the Woods, Banff, in the Laurentians and along the Saguenay and St. Lawrence rivers. The summer population of Algonquin Park during Thomson's years there was estimated to be about two thousand.

Georgian Bay, a large part of Lake Huron, lies to the northwest of Toronto, and is about the same

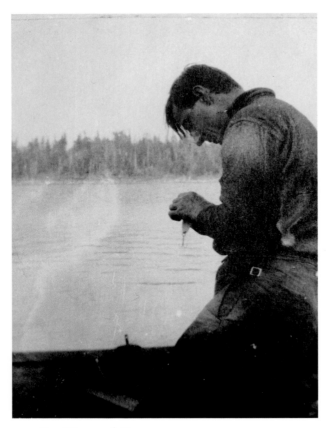

Tom Thomson fishing

parts of it with Jackson and MacDonald, and travelled by canoe along the French River to and from Algonquin Park. Thomson found a few subjects to paint on Georgian Bay and was always lured back to Algonquin Park, where he felt most at ease and was most inspired.

TRAVELLING IN THE BUSH

Algonquin Park and Georgian Bay became prime painting grounds for Thomson and his circle from 1913 to 1917. Indeed, the future members of the Group were sometimes referred to, informally or pejoratively, as the "Algonquin School" of painting before 1920, when they named themselves the Group of Seven. The early identification of the Group with this section of the Precambrian shield, with its fishing, boating, swimming, camping, and canoe travel, was stamped on all subsequent ideas about them, wherever else they subsequently painted. This summer playground evoked happy associations, since camping out was usually a pleasant adventure, with warm summer breezes, the scent of pines in the air, the wildlife chary but not invisible, the nights full of stars, and the autumn skies ablaze with the aurora borealis. Mosquitoes and black flies were seldom mentioned.

To travel into the wilderness in search of subjects, Thomson and his colleagues naturally resorted to the trusty cedar-strip canoe. The canoe had opened the Canadian wilderness to commerce, settlement, and European civilization, and was the favoured form of transportation in Algonquin Park, with its interconnected lakes, rivers, and portages, since it could be carried easily from lake to lake, and

distance from the city as Algonquin Park. The southern part is sprinkled with low islands, pinewoods cover the shores, and the inlets form intricate bays and passages. The northern part of the bay, above Manitoulin Island and the North Channel, has a more dramatic terrain of higher hills – the La Cloche area so beloved by Franklin Carmichael. Thomson had travelled through La Cloche in 1912 but did not return. Go Home Bay, where MacCallum had his cottage, was Thomson's base on Georgian Bay, although he explored other

could navigate moderate rapids and shallow water with comparative ease, while carrying a formidable load of supplies and equipment. Thomson became proficient at paddling, as did Jackson and most of the other members of the circle of friends, with the exception of MacDonald, who, Jackson reported, could neither paddle nor swing an axe.

MacCallum joined Thomson for some fishing in the early spring of 1917. Thomson had obtained his guide's licence, since he thought that the job of being a ranger – which he did briefly – bit into his time for painting too much.

The canoe was low and close to the water, and gave Thomson a point of view he used in many of his sketches. The aesthetic pattern thus created had an inch of foreground water painted along the bottom of a panel so that one looks across water toward a far shore, a device one can see in such paintings as *Sunset* and *Autumn Foliage*. The horizon is cut off by a bend in the river or a hill or a forest. The canoe was also, although clearly practical, somewhat old-fashioned and romantic, a recollection of earlier, braver, and possibly more adventuresome days in the country's history. In the public mind, the canoe was a link with Canada's earliest explorers and it gave the Group's work validity in the hearts of those who revered the country's pioneers.

Thomson's connection with the character of Algonquin Park cannot be underestimated. Jackson, even although he only knew Thomson for a year and a half before going overseas never to see him again, knew how profound that relation was: "The intimate charm with which he endows his waste of rock and swamp, friezes of spruce, the slim birch which clings to the meagre soil on the rocks, are but an expression of his love for the country."

However much wilderness, civilization, and exploitation overlapped in Algonquin Park, when Thomson arrived there the signature works, which would be forever associated with the Group of Seven, began to appear. Somehow, the combination of that terrain and the evolution of Thomson's painting style coaxed out of him sketches that embodied the atmosphere, colours, and forms that we recognize as uniquely Canadian. Thomson's paintings inspired and informed the work of his colleagues, particularly Jackson, Lismer, MacDonald, and Lawren Harris, who soon joined him there. Thomson, of course, had earlier learned from, and been influenced by, the work of Harris and MacDonald, so the mutual benefits these artists conferred on each other were substantial.

THOMSON AND THE LUMBER COMPANIES

When Thomson made Algonquin Park his spiritual home, the trade of the lumberman was a strong and powerful one. Canada's economy was driven by forestry, mining, fishing, and farming.

The country was caught up with the idea that its immense natural resources were a source of endless wealth to be exploited, and that those whose profession it was to extract the country's resources were the heroes of industry and society.

Thomson's interest in the logging business was keen and his portrayal of the flumes, dams, log jams, and other aspects of the timber industry permeated his work constantly. He painted and travelled in a terrain that had once been a virgin forest of immense white pines, yellow birches, tamaracks, spruces, and maples, but which had been, and to a large extent still was being, extensively logged by rapacious lumber companies. When he first visited the park in early 1914, Jackson gave these two descriptions of it:

> Round Canoe Lake is a ragged piece of Nature, hacked up many years ago by a lumber company that went broke. It is fire-swept, damned by both man and beaver, and overrun with wolves…

Thomson was much indebted to the lumber companies. They had built dams and log chutes, and had made clearings for camps. But for them, the landscape would have been just bush, difficult to travel in and with nothing to paint.

From these descriptions, Jackson was ambivalent about the benefits or predations of the lumber companies but the area gave him several masterpieces.

Thomson worked as a fire ranger in the summer of 1916, travelling along the Petawawa River, and following the Booth Company's log drive part of the way. His painting *The Drive* (unfinished) was one dramatic portrayal of this experience. His most stunning picture of the lumber industry is probably *The Pointers*. Originally called *The Pageant of the North*, it shows the large rowboats used to tow barges on which horses were transported from lake to lake, against a backdrop of autumn colour.

Thomson painted all the structures and machinery the lumber companies had abandoned: timber chutes and dams (like *Tea Lake Dam*), sluiceways, rotting flumes, old log jams, and the caterpillar-like "alligator" that hauled logs and log booms.

THE ORIGINS OF THOMSON'S STYLE

Thomson's art developed from a number of sources. First of all, of course, it came from the design work that he had spent most of his adult life doing, which depended upon a legible and tightly organized composition and punchy colours to impact the viewer. Allied to this was the aesthetic canon of the Art Nouveau movement of earlier years, with its serpentine botanical forms and elegant abstractions. These were most evident in Thomson's decorative panels for MacCallum's cottage and a few other works but they were, happily, replaced with a more original Expressionist approach to painting.

Two other major sources of inspiration are easily visible in Thomson's work: the influence of Impressionism, which he gleaned from his brief friendship with Jackson (who had become familiar with it in France) and also through Lismer, whose training in Brussels had exposed him to those artists as well. This exposure to Impressionism made Thomson into a brilliant colourist of the first order, and his ability to command a broad range of colour combinations set the work of his last years into a class by itself. Lismer also brought with him to Canada an intimate knowledge of John Constable, the father of landscape painting. MacDonald was also familiar with Constable, and Thomson's treatment of skies, so striking and powerful, was informed largely through his second-hand knowledge of Constable.

Thomson's working method also contributed to the formation of his personal style. The most lively of his work, and the most original, are the small wooden panels (about 20 cm x 25 cm / 8" x 10") he executed on the spot. Travelling by canoe and being in transit for days or weeks, these small panels were ideal for carrying. Moreover, they allow an immediacy that a pencil sketch and notes can never achieve. They force the artist to be quick and decisive in his emotional response to the subject, to compress a subject to its essentials, and yet to include every detail worth recording and to capture, as well, the emotional value of the subject.

These sketches could be and were used as the basis for larger canvases back at the Toronto studio. It was a common practice of many artists at the time to use the little oil sketches as the reference for a more elaborate work. In Thomson's case,

Self-Portrait: After a Day in Tacoma; c. 1902; watercolour; 22.9 cm x 15.2 cm (9" x 6"); Tom Thomson Memorial Art Gallery, Owen Sound.

although he also followed this method for some of his best-known work, the panel became an end, a sufficiently complete object. The Expressionist leanings that emerged in Thomson's panels in his last years gave an indication that he was moving toward a form of Expressionism that was remarkably intense. This was partly due to the influence of Harris, whose own work had the hard, bold edge of Expressionism imbedded in it, and whose work had the same pitch of emotional intensity.

TOM THOMSON'S ART

Thomson's great strength, once he had found his own voice as an artist, lay in the immediate response he had to what he saw in front of him. His visceral reaction to a subject was what animated his sketches, and he practically perfected the use and power of small panels, which he and his colleagues found so ideal (and convenient) to record their discoveries as they travelled throughout Canada.

Notwithstanding the ubiquity of the sketch-size paintings, all Thomson's artist friends knew that their real reputations as artists would rest upon the larger canvases that they created either from drawings or oil sketches. These were the works that had the proper heft and were given serious consideration by collectors, institutions, and exhibition societies.

The "working up" of the sketches into large canvases took place in his Toronto studio. In the process, as many comparisons prove, the larger canvas often lost the spontaneity of the original sketch. This had happened to the English painter John Constable too. The vitality that the moment of conception holds is often difficult to recapture at a later date or on a larger scale. Sustaining inspiration throughout the lengthier process of painting a larger work also presents major problems for most artists.

Thomson had several disadvantages as an artist. First, he had not trained as an artist and his formation was deficient just as his lack of knowledge about traditions was thin. He could not draw the human figure well at all. What he had that more than compensated for his shortcomings was a powerful intuitive sense, a passion for his subjects, an original eye for colour, and an unerring sense of scale in setting down his subjects.

PHOTOGRAPHY

Thomson was thoroughly familiar with the medium of photography, since it was not only a popular medium but used extensively in the design and printing houses where he worked. The early portraits of the Thomson family are a clear indication of photography's pervasive role in early twentieth century life, and there are several photographic portraits of Thomson at age sixteen, twenty, and older.

On his long two-month trip with William Broadhead – which took them from Biscotasing (northeast of Sault Ste. Marie) and ultimately down the Spanish River to Lake Huron in 1912 – Thomson carried a large supply of film and took a lot of pictures, presumably for his future use. These were all lost when their canoe capsized in a rapids. The reported loss of fourteen dozen rolls of film may be excessive, but the fact that only eight or so exposures per roll was common then may account for the large number. Nevertheless, such a large

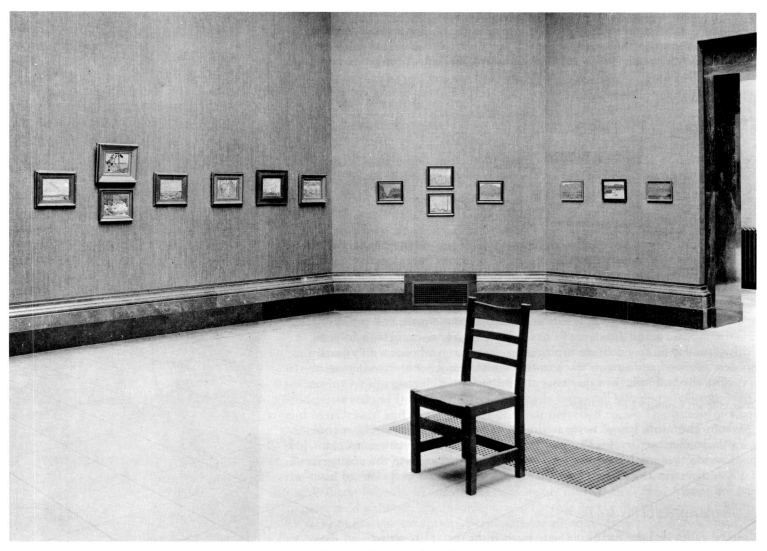

Installation photograph of the Tom Thomson Memorial Exhibition at the Art Gallery of Toronto, 1920.

number might indicate that Thomson did have some other purpose in mind in taking so many. What that purpose might have been is unknown, although the railways, according to Robson, were looking for material to promote the area.

Of the three dozen existing photographs that are believed to be by Thomson, none have the character of being taken to be used in his studio in Toronto for "working up" large canvases. For that, Thomson seems to have relied on his small oil sketches on panel, which incorporated colour and composition together. Rather, his photographs recorded, in a fairly ordinary way, what he saw.

EXHIBITIONS AND SALES

Thomson's first exhibition of his sketches was held at the Arts and Letters Club in 1911, when he was 34. It marked the real beginning of his brief career as an artist. A year later, his first major canvas, *A Northern Lake*, painted in the winter of 1912–13 after his first visit to Algonquin Park, was purchased by the Government of Ontario from the Ontario Society of Artists show for $250. At the time this amount represented nearly two month's salary at his then handsome rate of seventy-five cents an hour.

Thomson showed with the Ontario Society of Artists each year thereafter. In 1914 he was included in the Royal Canadian Academy exhibition and in the Little Pictures by Canadian Artists show at the Art Gallery of Toronto (now the Art Gallery of Ontario). The National Gallery bought *Moonlight, Early Evening* that year and, in December, Thomson contributed works to Canadian Artists in Aid of the Patriotic Fund, a Royal Canadian Academy war initiative.

Despite the war, the National Gallery managed another purchase in 1915: *Northern River* for $500. Thomson's work was also shown at the Canadian National Exhibition that fall and the Arts and Letters Club mounted another exhibition in December. The pattern for 1916 was about the same: the Ontario Society of Artists in the spring, the Canadian National Exhibition in the summer, and the Royal Canadian Academy in the fall.

When he returned from the war, Jackson's first tribute to Thomson's memory was to help arrange an exhibition at the Arts Club of Montreal in March of 1919. Jackson wrote the introduction to the catalogue. This exhibition was followed by the Memorial Exhibition of Paintings by Tom Thomson at the Art Gallery of Toronto in January and February of 1920.

Contrary to the Group of Seven's later complaints about the lack of recognition and sales, Thomson was praised and purchased, publicly and privately, as soon as he emerged as an artist.

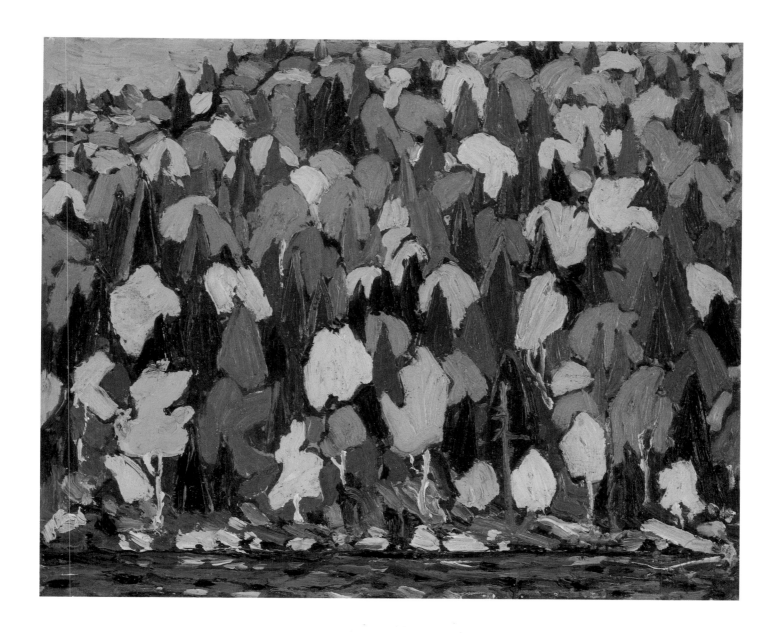

Autumn Foliage

21.6 cm x 26.7 cm (8½" x 10½"); Art Gallery of Ontario, Toronto.

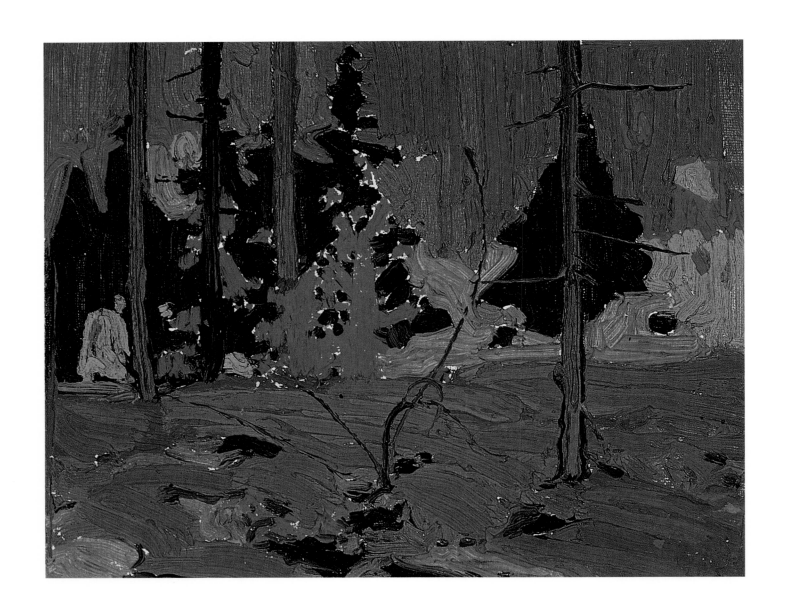

Autumn, Algonquin Park

21.6 cm x 26.7 cm (8½" x 10½"); Agnes Etherington Art Centre,
Queen's University, Kingston.

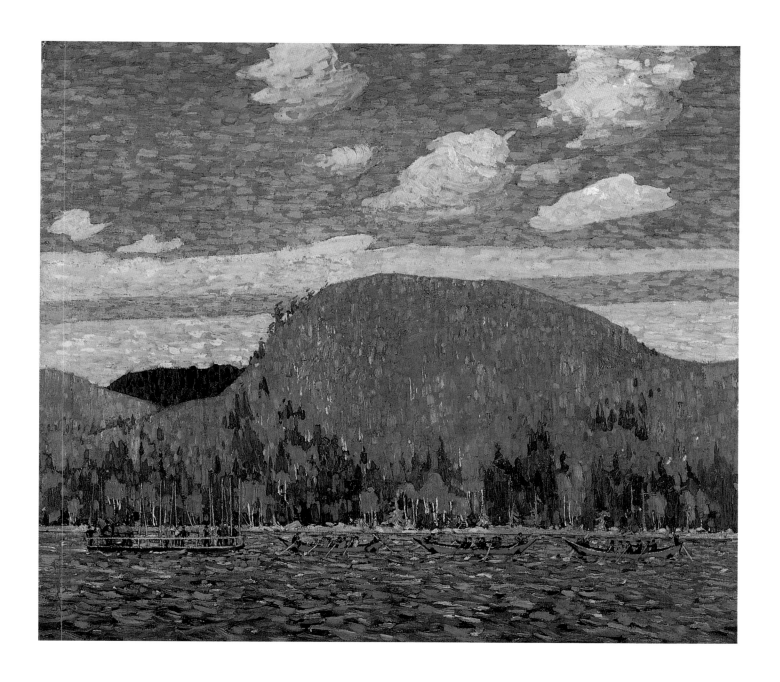

The Pointers

Oil on canvas; 101.6 cm x 45.6 cm (40¼" x 45½"); Hart House,
University of Toronto.

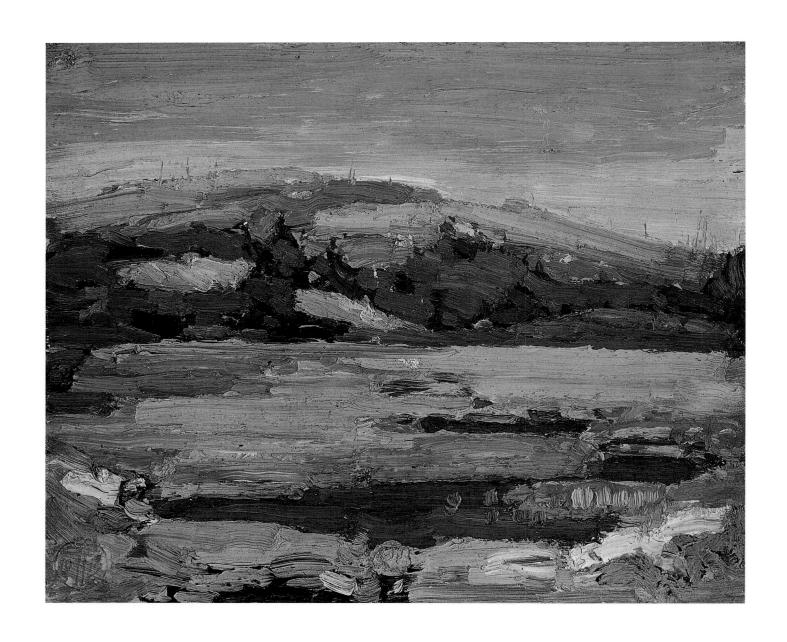

Cranberry Marsh

21.6 cm x 26.7 cm (8½" x 10½"); National Gallery of Canada, Ottawa.

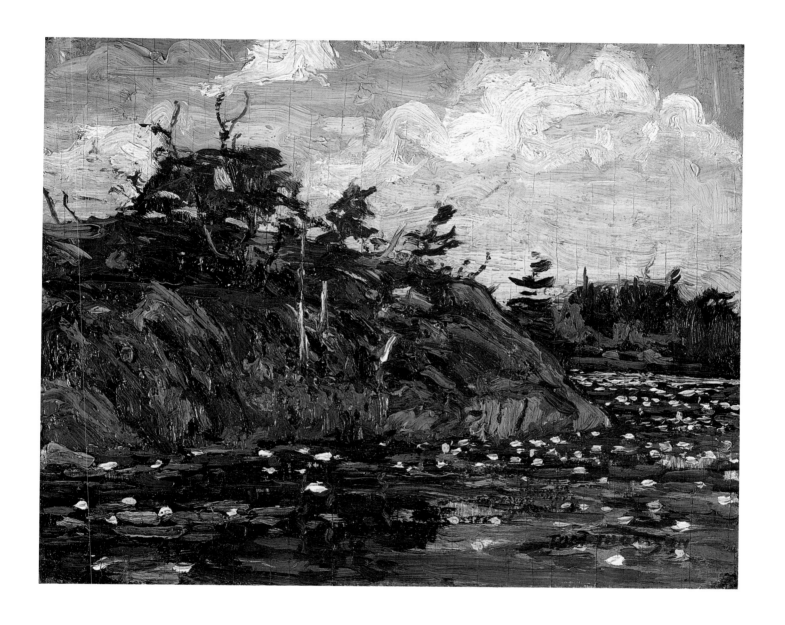

The Lily Pond

21.6 cm x 26.7 cm (8½" x 10½"); National Gallery of Canada, Ottawa.

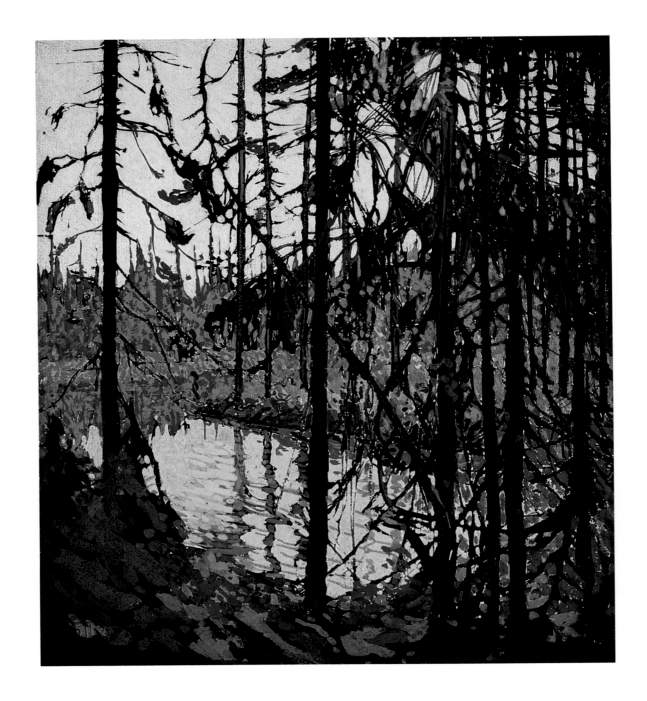

Northern River (sketch)

Watercolour on cardboard; 26.7 cm x 29.8 cm (10½" x 11¾").
Art Gallery of Ontario, Toronto.

Four: The Man and the Myth

TOM THOMSON'S DEATH

Probably no aspect of Thomson's life has been more thoroughly considered and dwelt upon than his death by drowning, which occurred in Canoe Lake, Algonquin Park, on 8 July 1917, barely a month before his fortieth birthday. The circumstances that surrounded his death have sparked endless speculation, most of it based on scanty evidence, and has spawned whole books, none of which have added anything to our appreciation of him as an artist.

Thomson's death was most acutely felt by those artists who had been closest to him as mentors, friends, and supporters. They were devastated by the sudden deprivation and no longer felt comfortable painting in Algonquin Park, since the memories of being there with Thomson were too raw to bear. J.E.H. MacDonald and William Beatty, in the absence of the others who were serving the war effort in various ways, went to Canoe Lake and erected a cairn to his memory. Beatty was already elderly and MacDonald was recovering from a stroke, but they lugged several tons of stones up to the top of a hill and cemented a plaque in place, which read:

To the memory of/Tom Thomson/artist, woods-man/and guide/who was drowned in Canoe Lake/July 8th 1917/He lived humbly but passionately/with the wild. It made him brother/to all untamed things of nature./It drew him apart and revealed/itself wonderfully to him./It sent him out from the woods/only to show these revelations/through his art. And it took/him to itself at last./His fellow artists and other friends and admirers/join gladly in this tribute to/his character and genius./His body is buried at/Owen Sound, Ontario, near/where he was born [sic] /*August*/*1877*

Thomson's death ("accidental drowning" was the official cause) was a great shock to his friends and to the art world. Although the war still raged in Europe, this single death, thousands of miles from the front lines, had almost as profound an effect on some people as the slaughter in the trenches. Here was Thomson, not yet forty, full of the greatest promise that had yet come along, and whose work was fulfilling a great expectation for an art that would give Canada its identity, and suddenly it was ripped away.

Of course, foul play was suspected, and Lawren Harris, among others, was of the opinion that

Thomson was murdered. His abilities as a canoeist, although only recently acquired, were so admired that an accident seemed impossible. Suggestions were made that he had had a dispute with Martin Bletcher, a German sympathizer, or a fight with someone over Winnie Trainor, to whom, it was rumoured, he was engaged to marry later that year or the next.

Thomson's body was recovered a week after he was last seen paddling out from Mowat Lodge. He had sustained a four-inch cut on his right temple, and his right ear had bled. One later story is that his feet were tangled in wire, but in fact Thomson had carefully wrapped copper fishing line around one ankle, which was either sprained or arthritic, and Mark Robinson, the ranger who helped recover the body, distinctly recalled cutting the line off the bloated corpse, wrap by wrap. Thomson was buried on 18 July, then exhumed, transported to Leith, and reinterred on 21 July.

Controversy began in earnest in about 1930 when Blodwen Davies whipped up speculation with the enthusiasm of a yellow journalist. Thomson's friends did not support this macabre turn. J.E.H. MacDonald refused to meet with Davies and wrote that it was "best for me to associate myself with the silence of an old friend" rather than join in the hysteria about how Thomson died. He knew that what really mattered was the work. But the hope of explaining the tragedy of loss did not subside.

In 1956, after suspicions that Thomson's body had not, indeed, been taken to the family plot at Leith, a judge named Little and three friends dug up Thomson's Canoe Lake gravesite (an illegal thing to do without permission) and found a skeleton that proved to be of Mongolian extraction. This only fuelled more speculation about Thomson's death, and practically guaranteed him renown in a way that had nothing to do with his painting. The mystery made him a legend, and he became the symbol of unfulfilled accomplishment in Canadian art.

MYTHOLOGIZING

The Thomson legend took on a life of its own in the national memory and everything about him became exaggerated. Reports of ghost canoeists became common currency at the Taylor Statten camps and among the cottagers of Canoe Lake. Theories of one kind and another abounded. Later, Thomson's life and controversial death became the basis for a novel, a play, a musical, and films. He was the romantic paragon, tall, handsome, single, moody, talented, passionate, and unattainable.

Thoreau MacDonald, J.E.H. MacDonald's son, said that Thomson "brought his sketches out of the bush as naturally as a hunter brings out fish or partridges," as if one went and bagged a painting that happened to be there. MacCallum added pastoral baloney to the legend by describing Thomson as spending the nights in his canoe: "motionless he studied the night skies and the changing outlines of the shores while beaver and otter played around his canoe." Thomson was confidently reported to have met the legendary Grey Owl and shared his oneness with nature; the Englishman Archie Belaney passed through Algonquin Park while Thomson was still alive and they may have met, but his persona as Grey Owl did not emerge for another decade.

Lismer wrote, "I've been with him in the woods

when I've got the definite feeling that he was part of them, when the birds and animals recognized something in him that they had themselves. That's why I say that the rest of us were painting pictures; he was expressing moods. He was simply part of nature." Harris shared this view of Thomson as a "child of nature" and Jackson would have subscribed to it too. His intuitive sense in relation to the land and the light was so strong and subtle that, at his best, he was unmatched by any of his colleagues.

The art writer Graham MacInnes wrote in 1938 that MacDonald was the better painter of the two, but Thomson the better artist. He might have said the same of Harris and Thomson, or even Jackson and Thomson. The reason Thomson's work appeals so to us today and to his fellow artists then as now, is not because of his formal attributes, his aesthetic devices, his brilliant colour, or his subjects, but because his work has the highest emotional pitch and intensity.

HAROLD TOWN (1924–90) ON TOM THOMSON

The following excerpts were written by Harold Town, the leading artist of his generation, in "The Pathfinder" and Tom Thomson: The Silence and the Storm *(see Sources and Further Reading). His admiration of Thomson was one shared by nearly all contemporary artists, who acknowledged Thomson as a master and his work as a source of inspiration.*

Thomson's small oil sketches of the last years palpitate and throb. They are as direct in attack as a punch in the nose, and the sense of movement in them has the sweep and pull of a paddle entering water. Paint is thrust and smashed onto the board with axe-like swings; it seems almost a substitute for the coarse fare of the bush, making of the final picture a banquet for Thomson's Spartan senses. "To him his most beautiful sketches were only paint," to quote his benefactor, Dr. MacCallum. It would not surprise me to find that Thomson had eaten some paint in sheer love of its completeness and tactile affinity to the tumult of colour around him in the bush.

Thomson could manipulate a brush with easy virtuosity, hesitating in the middle of a stroke, turning abruptly during sweep, flattening and extending the width, contracting, rolling the hair to its edge without, like a great baseball pitcher, losing his rhythm.

Thomson was a master colourist. Rarely did he miss the mark, and then inexplicably with those canvases containing a sizable amount of red. In large portions this colour upset his judgment and he lost the ratio between local colour values, and consequently the middle tones became strident in hue.

It is the confluence of explosive power and imprisoned impulse that agitates the work of the final period, a force of application that hums with frustration and yearns for action – a consuming appetite for paint fed on too small a fork.

At the time of his death a perturbed Thomson was poised on the crevasse between figurative and non-figurative art. Whether he would have survived the jump is a matter of conjecture; that he would have jumped is, to me at least, a certainty.

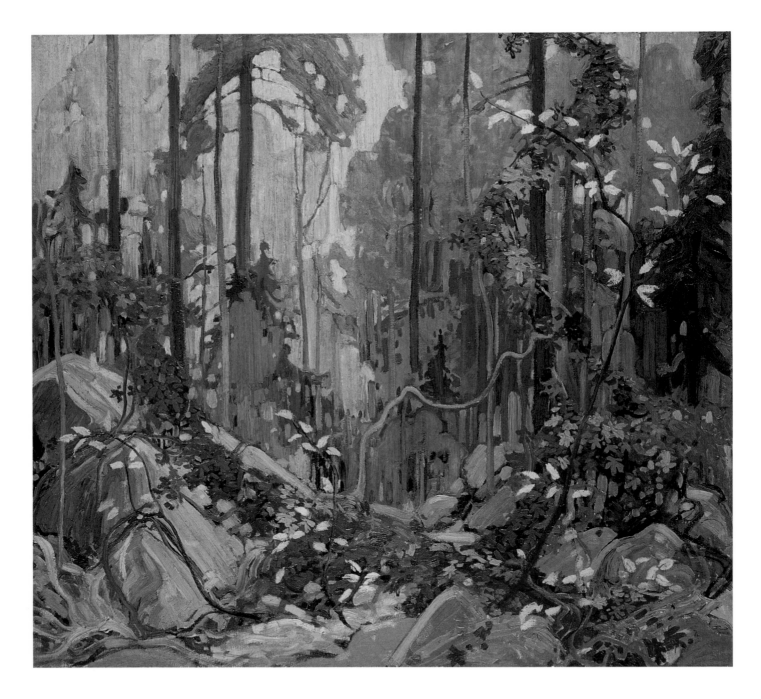

Autumn's Garland

1915–16; oil on canvas; 122.5 cm x 132.2 cm (49" x 52⅞"); National Gallery of
Canada, Ottawa. Purchased 1918. No. 1520.

Sources and Further Reading

Arts Club of Montreal. *Catalogue of an Exhibition of Paintings by the Late Tom Thomson, March 1 to March 21, 1919.* Foreword by A.Y. Jackson.

Art Gallery of Toronto. *Catalogue of a Memorial Exhibition of Paintings by Tom Thomson, and a Collection of Japanese Colour Prints Loaned by Sir Edmund Walker.* Toronto: Art Gallery of Toronto, 1920.

Frye, Northrop. "Canadian and Colonial Painting." *Canadian Forum* 20, No. 242 (March 1941): 377–8. Reprinted in *The Bush Garden: Essays on the Canadian Imagination,* Toronto: Anansi, 1971, 199–202.

Harris, Lawren Stewart. *The Story of the Group of Seven.* Toronto: Rous and Mann Press, 1964.

Housser, F.B. *A Canadian Art Movement: The Story of the Group of Seven.* Toronto: MacMillan, 1926.

Jackson, A.Y. *A Painter's Country: The Autobiography of A.Y. Jackson.* Toronto: Clarke, Irwin and Co. Ltd., 1958. Further ed., 1967.

McInnes, Graham, producer and director. *West Wind.* Video recording, VHS, of a 1944 production. Montreal: National Film Board of Canada, 1995. French-language ed., *Bourrasque.*

Mellen, Peter. *The Group of Seven.* Toronto: McClelland and Stewart, 1970. French-language ed., *Le Groupe des sept,* Laprairie, Que.: Éditions Marcel Broquet, 1980. Rev. English-language ed., 1981.

Murray, Joan. *The Art of Tom Thomson.* Exhibition catalogue. Toronto: Art Gallery of Ontario, 1971. French-language edition, *L'art de Tom Thomson.*

——. *Impressionism in Canada: 1895–1935.* Exhibition catalogue. Toronto: Art Gallery of Ontario, 1973 (c. 1974).

Nasgaard, Roald. *The Mystic North: Symbolist Landscape Painting in Northern Europe and North America, 1890–1940.* Publication for an exhibition at the Art Gallery of Ontario, Toronto. Toronto: University of Toronto, 1984.

Newlands, Anne. *The Group of Seven and Tom Thomson: An Introduction.* Willowdale, Ont.: Firefly Books, 1995.

Reid, Dennis, editor. *Tom Thomson.* Vancouver: Douglas & McIntyre, 2002.

——. *Tom Thomson: "The Jack Pine"/Tom Thomson: "Le pin."* Masterpieces in the National Gallery of Canada series. Ottawa: National Gallery of Canada, 1975.

——. *The MacCallum Bequest of Paintings by Tom Thomson and Other Canadian Painters and the Mr and Mrs H.R. Jackman Gift of the Murals from the Late Dr MacCallum's Cottage Painted by Some of the Members of the Group of Seven/Le legs MacCallum, peintures par Tom Thomson et par d'autres peintres canadiens et le don de M. et Mme H.R. Jackman de panneaux décoratifs du chalet de feu le Dr MacCallum peints par quelques-uns des membres du Groupe des sept.* Ottawa: Exhibition catalogue. Ottawa: National Gallery of Canada, 1969.

Silcox, David P., and Harold Town. *Tom Thomson: The Silence and the Storm.* Toronto: McClelland and Stewart, 1977. French-language ed., *Tom Thomson, le calme et la tempête,* Laprairie, Que.: Éditions Marcel Broquet, 1983. 4th English ed., with new Preface, Firefly Books, 2001.

Tom Thomson Memorial Art Gallery, Owen Sound, Ont. *Tom Thomson and the Group of Seven: Opening Exhibition, May 27 to June 11, 1967.* Exhibition catalogue. Owen Sound, 1967.

Town, Harold. "The Pathfinder." In *Great Canadians: A Century of Achievement,* selected by Vincent Massey et al., pp. 108–10. Canadian Centennial Library. Toronto: Canadian Centennial Publishing Co., 1965.

Index